Aftermath: Art in the Wake of World War One

Edited by Emma Chambers

First published 2018 by order of the Tate Trustees
by Tate Publishing, a division of Tate Enterprises Ltd,
Millbank, London SW1P 4RG
www.tate.org.uk/publishing

On the occasion of the exhibition
Aftermath: Art in the Wake of World War One

Tate Britain, London
5 June – 23 September 2018

Supported by Tate Patrons

A catalogue record for this book is available from
the British Library

ISBN 978 1 84976 567 1

Distributed in the United States and Canada by ABRAMS,
New York

Library of Congress Control Number applied for

Project Editor: Alice Chasey
Production: Roanne Marner
Picture Researcher: Emma O'Neill
Designed by Lorenz Klingebiel
Colour reproduction by Altaimage, London
Printed and bound in Italy by Graphicom SPA

Front cover: George Grosz, *Grey Day* 1921 (detail of no.77)

Measurements of artworks are given in centimetres,
height before width, before depth

Contents

Director's Foreword

Aftermath: Art in the Wake of World War One is Tate Britain's contribution to the exhibitions and events that will be taking place in 2018 to mark the centenary of the end of the First World War. It is the first exhibition to examine both the culture of remembrance and the social and aesthetic impact of the First World War on art in Britain, Germany and France in the period 1916–1932. The war was a global event that impacted on visual culture around the world, but these three countries were selected because of the significance of their memorial art, and the important roles played by the London, Berlin and Paris art worlds in shaping visual culture in the interwar years. Important developments occurred elsewhere, notably in Italy, Russia and America, but these lie outside the scope of this exhibition, as does Adolf Hitler's inauguration of a new phase of state-control of art in Germany in 1933. From the first it was important for us to present this period through a shared European history rather than confining it to a national story, allowing us to explore the synergies and differences in approaches to remembering the war through the visual arts in the three countries. The exhibition reflects Tate Britain's commitment to relating British art to social history and to considering the dialogues with international art that informed the work of British artists.

Aftermath explores how memories of the war were filtered through specific cultural forms and political agendas. It is unusual in bringing together artworks specifically commissioned to remember the war, such as battlefield landscapes and memorial sculpture, with art associated with the formal and intellectual developments of the 1920s such as dada and surrealism which created new visual forms to process experiences and memories of the conflict. In this way we hope to illuminate the profound impact of artists' war experiences on their work after the conflict, whether through the ubiquity of fragmented and machine-like figures reflecting the presence of disabled veterans in society or through a reawakened interest in religious imagery and nostalgic landscape, showing how both traditional and avant-garde art forms were part of the processing of memories. The exhibition also examines artists' comments on post-war society, from critiques of post-war corruption and poverty to visions of

reconstruction and social equality. Although the post-war years were ones of reflection and mourning, they also saw a desire to build a better world with the extension of the vote to all men and some women in Britain and Germany and advances in technology and architecture.

Our examination of this important subject has only been possible because of the extraordinary generosity of our lenders who have parted with some of the most important works in their collections. In particular the Imperial War Museum, Berlinische Gallery, Nationalgalerie, Berlin, Bibliothèque de Documentation Internationale Contemporaine (BDIC) and the Musée national d'art moderne, Centre Pompidou have been exceptionally supportive in their loan of significant groups of work to the show. I would like to reiterate our thanks to all the institutional and private lenders, who have supported the exhibition with enthusiasm and generosity, and without whom exhibitions such as this would not be possible.

Aftermath has been curated by Emma Chambers, Curator of Modern British Art with Rachel Rose Smith, Assistant Curator, Modern British Art assisted by Zuzana Flaskova, Curatorial Assistant and Camille Feidt, intern from the Courtauld Institute of Art MA course *Curating the Art Museum*. Catalogue contributors Simon Martin, Catherine Moriarty, Dorothy Price and Michael White have enriched our understanding of the imagery and themes which emerged in response to the experiences of war in their essays exploring new developments and shared ideas in British, French and German art in the period.

We are also very grateful to Tate Patrons for their generous support towards the presentation of the exhibition. The exhibition has been made possible by the provision of insurance through the Government Indemnity Scheme. Tate Britain would like to thank HM Government for providing Government Indemnity and the Department of Digital, Culture, Media and Sport for arranging the indemnity.

Alex Farquharson
Director, Tate Britain

Aftermath

by Emma Chambers

The physical aftermath of the First World War can be counted in the bodies of dead and wounded soldiers and civilians and the destruction of buildings and landscape. More than ten million soldiers died and more than twenty million were wounded, while large areas of Northern France and Belgium were left as ruined wastelands.[1] Memorial painting and sculpture offered a direct response to these losses and provided a focus for mourning and remembrance. But the psychological impact of the war was seen in other art forms, from dada and surrealism to religious and landscape painting. These works were haunted by the spirits of the dead and shaped by the damaged bodies and minds of the survivors.[2]

Artists began to explore new imagery and new ways of making art in their responses to the experience of war, the culture of remembrance, and the reconstruction of cities and societies. Analysis of these responses has often separated war and memorial art from aesthetic developments in the art of the 1920s and 1930s and the dialogue that took place between tradition and the avant-garde in these decades. *Aftermath* seeks to bring together these interlinked narratives of aesthetic and commemorative developments comparing the impact of the First World War on visual art in Britain, Germany and France between 1916 and 1932.

Two bold sculptural statements made during the war show how artists began to respond to the huge casualties of the First World War with a new awareness of the fragility of the human body. When Jacob Epstein first made *Rock Drill* the aggressive visored figure was mounted on a mechanical drill to convey the menace of a machine-like robot (fig.1). In 1916, shocked by news of the terrible effects of mechanised warfare, Epstein removed the drill and amputated the figure's lower limbs, transforming it into a vulnerable emasculated figure (no.2). Wilhelm Lehmbruck's *The Fallen Man* 1915–16 (no.1) drew on his experience as a medical orderly in a military hospital in Berlin to produce a figure in anguished collapse, repudiating heroic imagery of the fallen soldier.

In artists' depictions of the battlefields of the Western Front shattered landscapes of mud, shell craters and broken trees obliquely conveyed the loss of human life through the destruction of nature.[3] These landscapes of the aftermath of battle evoked silence and absence. The motif of the abandoned helmet was a poignant symbol of an individual soldier's death shared by British, French and German artists,

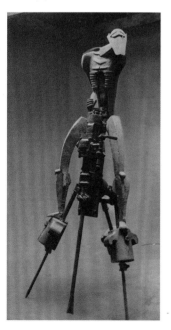

Fig.1
Rock Drill in Jacob Epstein's studio, c.1915, Vintage print, Leeds Museums & Galleries (Henry Moore Institute Archive)

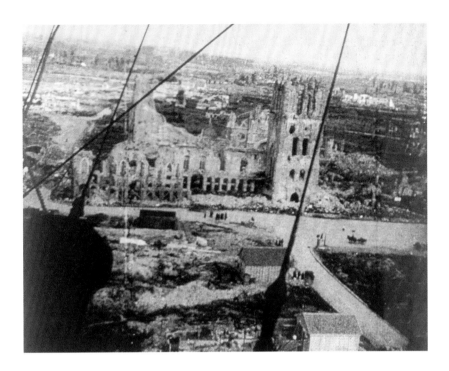

and simple wooden crosses marked the makeshift battlefield graves where fallen soldiers were buried before the creation of official cemeteries which brought a geometry and order to mass death (nos.3–8).

Although death was always implied in these landscapes, the depiction of the bodies of dead soldiers was more controversial and C.R.W. Nevinson's *Paths of Glory* (no.7) was banned by the military censor. Nevinson exhibited it in 1918 covered with a strip of brown paper inscribed 'censored', generating widespread publicity which highlighted controls over the images of war presented to civilians. Battlefield landscapes became the focus of pilgrimage and collecting after the war, as ruined towns and sites of battle in France and Belgium were documented in tourist guides and postcards and film (fig.2), and souvenir objects such as helmets, bullets and shrapnel were collected.[4]

In 1918 British artists were commissioned to make paintings for a 'Hall of Remembrance' to celebrate national ideals of heroism and sacrifice.[5] Both established and younger artists including John Singer Sargent, Philip Wilson Steer, Charles Sims, David Young Cameron, Wyndham Lewis, Stanley Spencer, Paul Nash, C.R.W. Nevinson and William Roberts painted huge canvases for the project using the history paintings of the Renaissance as their model (see nos.9, 12). The hall was never built, but the works were shown together in the exhibition *The Nation's War Paintings* at the Royal Academy in 1919.

Britain was unusual in commissioning a scheme of paintings as a war memorial, but sculpted war memorials had a central role in the commemoration of the war in all three countries. The Fêtes de la Victoire in Paris on 14 July 1919 and the Peace Day Parade in London on 19 July 1919 both used a Cenotaph or empty tomb as a national focus for remembrance (nos.13–17). Only Britain's Cenotaph became a permanent memorial, its abstract architecture 'intended to represent

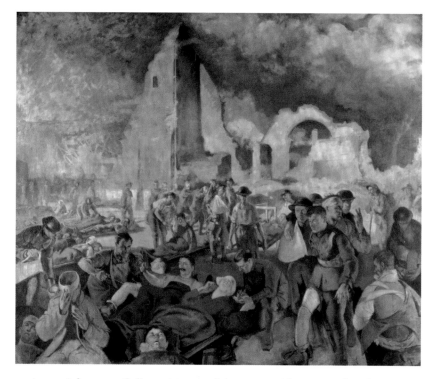

an imperial grave of all … citizens of the empire'.[6] In 1920 the absent
and unidentified bodies of the dead were powerfully symbolised by the
inauguration of the tombs of the Unknown Warrior in Westminster Abbey
in London (nos.13–14) and the *Soldat inconnu* at the Arc de Triomphe in
Paris on 11 November, providing a surrogate body for the grieving fami-
lies of the missing.[7] As the defeated nation, Germany's memorial culture
was naturally very different, both contested and regionalised: no national
ceremonies were held to mark the end of the war and the concept of the
Unknown Soldier proved divisive in Germany's fractured political cli-
mate.[8] No national memorial existed until the eighteenth-century Neue
Wache building in Berlin was designated for this purpose in 1931.[9]

Rituals focused on war memorials were an agent of social cohesion
in times of political unrest and carried the memories of the war
on into peacetime.[10] However, these memorials to the dead failed
to acknowledge the sacrifices of soldiers who had returned from
war permanently disabled through psychological damage, the loss of
limbs or terrible injuries to the face. In the postwar period, veterans
in all three countries, often unemployed and living in poverty
due to inadequate state pensions, struggled to resume a normal life.[11]

How wounded soldiers were represented in Britain, Germany
and France reveals contrasting approaches to remembering the First
World War through the living and the dead. Henry Tonks' portraits
of soldiers with severe facial injuries (nos.29, 30) were only seen in a
medical context at the time, although they have since become famous.
British painting and popular imagery instead presented the public with
heroic images of lightly wounded soldiers (fig.3), while the primary
focus of commemorative activities was on the valiant dead.[12] Disabled
veterans did not take part in the Peace Day Parade; instead they were

restricted to special grandstands, drawing criticism that while the
Cenotaph at the centre of the ceremonies represented the dead, the
sacrifices of the wounded were unacknowledged.[13]

In France, on the other hand, the wounded were highly visible.
On 28 June 1919, five representatives from the Val de Grâce hospital
in Paris attended the signing of the Versailles Treaty at the invitation
of the French Prime Minister Georges Clemenceau, to serve as
a reminder to delegates of the violence and brutality of war (fig.4).
Disabled veterans also featured prominently in the Fêtes de la Victoire
and official photographs recording the event, ensuring that they
became an integral part of the visual memory of the end of the war.[14]
This visibility continued into the 1920s with the formation of the
Union des Blessés de la face et de la tête (Association of the Wounded
of the Face and Head), colloquially known as 'les gueules cassées'
('the broken faces'), to promote the cause of veterans with facial injuries.[15]

In Germany, graphic images of the wounded were widely circulated
in both anti-war literature and art. The socialist activist Ernst Friedrich's
Krieg dem Kriege! (*War Against War!*) (no.38) juxtaposed official
patriotic and militarist propaganda images with shocking images of
horrific war injuries. Imagery of disabled veterans was also used by artists
such as Otto Dix and George Grosz to make trenchant criticisms of
post-war German society (nos.39, 41). Alongside this imagery, the visibil-
ity of disabled veterans in the society of all three countries was a constant
reminder of the terrible cost of war. It constituted an alternative war
memorial, in flesh rather than stone, that showed the lasting physical
impact of the war on individuals in peacetime, rather than symbolising
sacrifice through an idealised or absent universal soldier.

In the 1920s dada artists including Hannah Höch and John Heartfield
embraced the medium of collage to make pointed juxtapositions
of images that contested the way that the war was being remembered
(nos.45, 47).[16] Kurt Schwitters made his *Merz* pictures from rubbish,
responding to the turbulent atmosphere in Germany in the aftermath of
defeat. He wrote: 'Everything had broken down … new things had to

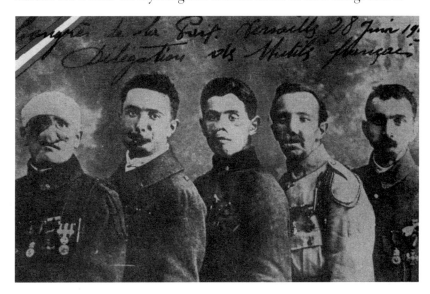

Fig.4
Delegation of the Mutilés
Français at the signing
of the Versailles Peace Treaty,
28 June 1919

be made from fragments … new art forms out of the remains of a former culture'.[17] The disabled veteran with prosthetic limbs inspired automaton figures that combined flesh and machine parts, and evoked anxieties about the fragility and fragmentation of the male body.[18] Both George Grosz and John Heartfield spent a part of their military service undergoing psychiatric treatment, and their collaborative sculpture *The Petit-Bourgeois Philistine Heartfield Gone Wild (Electro-Mechanical Tatlin Sculpture)* 1920 (no.42) embodies both the physical and the psychological impact of the war. A tailor's dummy with a mannequin's leg and a metal prosthesis, decked out with military and mechanical objects including a gun, a door-bell, a set of false teeth and military medallions, the figure was designed to be plugged into an electrical socket to illuminate the light bulb that formed his head. The mismatching mechanical limbs suggest the prosthetics worn by disabled veterans, while the electrification alludes to common electric shock treatments for shellshock.[19]

The damage which the war had inflicted on male bodies and minds also shaped surrealist art and writing. Both André Breton and Louis Aragon, founders of the Surrealist movement, had been medical students at the military teaching hospital at Val de Grâce in Paris in 1917 and had first-hand experience both of the *mutilés de guerre* who were patients there and the medical objects which recorded its work.[20] Surrealism channelled the hysterical symptoms of shellshock in its irrational practices and displaced anxieties about a vulnerable and damaged masculinity onto the fragmented female form (nos.43–44).[21] As the French government sought to stabilise the country through social and economic programmes promoting a return to traditional family values, the surrealists deliberately distorted gender roles and emphasised sexuality, aiming to destabilise rational thought and social order.

Simultaneously, the experience of the catastrophic impact of modern warfare resulted in a retreat from the geometric and mechanised forms that had been at the heart of avant-garde movements such as cubism and vorticism before the war. The revival of realism and resurgence

Fig.5
Otto Griebel
The International 1928–30
Oil paint on canvas,
125 × 185
Deutsches Historisches
Museum

Fig.6
Ludwig Mies van der Rohe
*Competition Entry for
a Sky-Scraper at Friedrichstrasse
Railway Station, Perspective View*
1921, Photograph, reworked
in various media, Bauhaus Archiv,
Berlin

in traditional genres such as portraiture, religious paint-
ing and landscape that followed became known as the
'return to order' (see pp.72–95).[22] The return to order
represented more than a return to traditional practices,
instead taking realism in new directions and often
aligning it with concepts of national identity. In France
the rediscovery of classicism was thought to express the
values of civilisation and tradition, while Germany's *Neue
Sachlichkeit* ('New Objectivity') painters focused on ren-
dering the materiality of everyday life with precision and
clarity, seeking through this meticulous realism to regain
control amidst a chaotic economic and political climate.[23]

The female portrait was one of the key genres of
Neue Sachlichkeit, and also prominent in British realist
painting of the 1920s. The sitters in Meredith Frampton's,
Christian Schad's and Rudolf Schlichter's paintings
(nos.72, 73, 75) all conform to a distinctive type of femi-
ninity which emerged in the postwar period in Britain and
Germany: the '*Neue Frau*' or 'new woman'. In Britain
and Germany, women were able to vote for the first
time in 1918, and their position in society had altered as
a result of their having taken on male jobs during war-
time.[24] Social unrest and political upheaval was intense
in the 1920s, particularly in Germany, where inflation and mass
unemployment resulted in acute disparities between different sections
of society. Many Neue Sachlichkeit artists tackled social themes from
a political perspective and George Grosz's *Grey Day* 1921 (no.77)
explores the impact of the war on a series of social types: the disabled
former soldier, the dehumanised and robotic factory worker, and
the prosperous bureaucrat, a 'State functionary for the Welfare of the
War Disabled' who ignores his disadvantaged compatriots, suggesting
that despite the upheaval of the war society has reverted to its old
class divisions.[25]

Artists commented acerbically on the unequal fortunes of those who
had stayed at home and those who had fought for their country with
the figure of the profiteer providing a focus for social comment (no.79).
Many artists – including Otto Griebel, Wilhelm Lachnit and Clive
Branson – were committed socialists in this period and used their work
to argue for a more equal society, promoting the ordinary worker as a
heroic monumental figure. Griebel's *Die Internationale* 1928–30 (fig.5)
depicts a crowd of workers singing the famous socialist anthem, powerful
in their unity, as a statement of hope for a fairer future.

As artists considered reconstruction and renewal in the 1920s,
they frequently looked to the example of America. Jazz and dance
culture swept London, Berlin and Paris, and American architecture also
influenced ideas of how cities might be reconstructed. The Bauhaus
School, founded in Weimar in 1919, had a social agenda that aimed
to shape the modern world through the integration of art into society;
Mies van der Rohe imagined how Berlin's Friedrichstrasse might be
transformed by skyscrapers (fig.6), while Oskar Schlemmer's abstracted

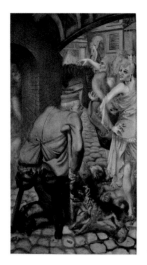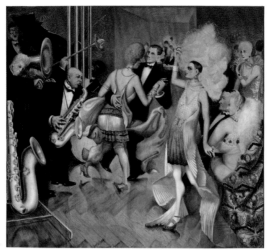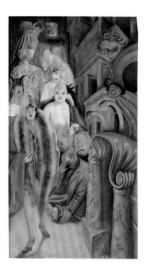

figures constructed a universal conception of man for modern times. The skyscrapers of New York featured in cityscapes by Nevinson, Paul Citroen and El Lissitzky (nos.91, 92, 95), while in Europe the Berlin Radio Tower, constructed 1924–6, was a symbol of technical progress and modernity (no.90).

Two contrasting visions of the city were presented in the 1920s by Fernand Léger and Otto Dix. Léger extolled the beauty of machinery in his lecture *The Machine Aesthetic* (1923) and his film *Mechanical Ballet* (1924) (no.100). He was fascinated by the automated production processes of American factories, and in his painting *Discs in the City* 1920 (no.89) he portrayed a dynamic mechanised city where tiny human figures are dominated by a landscape of wheels and pulleys, in a utopian vision of a technological future.[26] Dix's *Metropolis* 1927–8 (fig.7) presents the city as a hotbed of decadence and moral corruption: the central panel conveys the hedonistic abandon of Berlin nightlife in the 1920s, while on the left and right panels prostitutes are juxtaposed with disabled war veterans. Both groups are victims of war, the veterans reduced to begging in the streets and emasculated by their injuries, while economic necessity has forced the women into prostitution. Dix vividly conveys the impoverished and powerless status of war veterans alongside the anxiety that female sexuality and shifting gender roles evoked in post-war Germany.[27]

The First World War cast a long shadow over the art of the 1920s. The sense of a period of aftermath – an agricultural term referring to the new grass that grows immediately after reaping – suffused artists' practice as they created works that reflected on the death, destruction and social upheaval caused by the war, but also imagined how society might be reconstructed to create a brighter future. **EC**

Fig.7
Otto Dix
Metropolis 1927–8
Mixed media on wood,
181 × 402, Kunstmuseum
Stuttgart

1 For a recent analysis and collation of statistics see Antoine Prost, 'War Losses' in *1914-1918-online: International Encyclopedia of the First World War*, ed. U. Daniel et al, Berlin 2014. DOI: 10.15463/ie1418.10271.

2 See Jay Winter, *Sites of Memory, Sites of Mourning: The Great War in European Cultural History*, Cambridge 1995.

3 The British government's Official War Artist Scheme, which employed salaried artists to document the war, began in 1916. Also in 1916, France established a 'Mission aux armées' which offered an opportunity for artists to visit the Front at their own expense and risk. In Germany, artists could apply for a permit to tour to the Front, often under private or semi-private arrangements. See Sue Malvern, 'Art', *1914-1918-online*. DOI: 10.15463/ie1418.11006.

4 See Daniel J. Sherman, *The Construction of Memory in Interwar France*, Chicago and London 1999, pp.35–49.

5 Sue Malvern, *Modern Art, Britain and the Great War: Witnessing, Testimony and Remembrance*, New Haven and London 2004, pp.76–89.

6 Andrew Bonar Law, 1919. Quoted in Catherine Moriarty, 'The Absent Dead and Figurative First World War Memorials', *Transactions of the Ancient Monuments Society*, vol.39, 1995, p.15. The Paris Cenotaph was criticised for its Germanic style and dismantled after the ceremony: see Winter 1995, p.103.

7 Adrian Gregory, *The Silence of Memory: Armistice Day 1919-1946*, Oxford 1994, pp.23–8; Sherman 1999, pp.100–3; David Cannadine, 'War and Death: Grief and Mourning in Modern Britain' in Joachim Whaley (ed.), *Mirrors of Mortality: Studies in the Social History of Death*, London and New York 1981, pp.227–30.

8 Volker Ackermann, 'La Vision Allemande du Soldat Inconnu: Débats Politiques, Reflexion Philosophique et Artistique' in Jean-Jacques Becker (ed.), *Guerre et Cultures: 1914-1918*, Paris 1994.

9 See George L. Mosse, *Fallen Soldiers: Reshaping the Memory of the World Wars*, New York and Oxford 1990, pp.97–8, and Ackermann 1994, pp.385–96 (p.388).

10 See Gregory 1994, pp.8–18; Cannadine 1981, pp.219–25.

11 See Deborah Cohen, *The War Come Home: Disabled Veterans in Britain and Germany 1914–1939*, Berkeley, CA and London 2001, and Antoine Prost, *In the Wake of War: Les anciens combatants and French Society*, Oxford, 1992.

12 Joanna Bourke, *Dismembering the Male: Men's Bodies, Britain and the Great War*, London 1996, pp.212–13, 232–3.

13 Cohen 2001, pp.101–2. Three blinded veterans were present at the inauguration of the Tomb of the Unknown Warrior in Westminster Abbey in 1920: see Gregory 1994, p.53.

14 The procession was led by four 'grands mutilés', followed by one thousand mutilés. See Stéphane Audoin-Rouzeau and Annette Becker, *1914-1918: Understanding the Great War*, London 2002, pp.194–6.

15 Sophie Delaporte, *Gueules Cassées: Les blessées de la face de la Grande Guerre*, Paris 2004.

16 Michael White, *Generation Dada: The Berlin Avant-garde and the First World War*, New Haven and London, 2013, pp.16-21.

17 Quoted in John Elderfield, *Kurt Schwitters*, New York, 1985, p.12.

18 Brigid Doherty, '"We Are All Neurasthenics!" or, the Trauma of Dada Montage', *Critical Enquiry*, vol. 24, no. 1, Autumn 1997, pp.84-5.

19 Doherty, pp.118-121.

20 Amy Lyford, *Surrealist Masculinities: Gender Anxiety and the Aesthetics of Post-World War 1 Reconstruction in France*, Berkeley, CA 2007, pp.47–79.

21 Ibid., pp.1–14.

22 Christopher Green, *Cubism and its Enemies*, New Haven and London 1987, pp.187–202; Kenneth E. Silver, *Esprit de Corps: The Art of the Parisian Avant-Garde and the First World War 1914–1925*, London 1989.

23 Patrick Elliott, 'Sculpture in France and Classicism 1910–1939', in Jennifer Mundy (ed.), *On Classic Ground*, exh. cat., Tate, London 1990, p.290. Wieland Schmidt, *Neue Sachlichkeit and German Realism of the Twenties*, cat. no., Hayward Gallery, London 1979, pp.13–15.

24 In Germany women over the age of 20 were granted the right to vote, in Britain it was propertied women over the age of 30. France did not grant women the right to vote until 1948.

25 Matthias Eberle, *World War One and the Weimar Artists*, New Haven and London, 1985, p.68.

26 See Christopher Green, *Art in France 1900–1940*, New Haven and London 2000, pp.157–8.

27 Dorothy Rowe, *Representing Berlin: Sexuality and the City in Imperial and Weimar Germany*, Aldershot 2003, pp.167–79.

Making the Absent Present

by Catherine Moriarty

'The fighting was over. The Army was nothing – harmless! Why should they trouble about these men? Why upset themselves and their pleasures by remembering the little upturned hands on the duckboards, or the bodies lying in the water in the shell-holes, or the hell and bloody damnation of the four years and odd months of war, or the men and their commanders who pulled them through from a bloodier and worse damnation and set them up to dictate a peace for the world?'[1]

Sent to paint the Peace Conference in Paris in 1919, William Orpen observed the frock-coated politicians, the 'frocks' as he called them, engaged in the business at hand. Standing in the Hall of Mirrors at Versailles, Orpen considered the tension created by both the absence and presence of the recent past in the transactions taking place before him. Having completed two of the three paintings he had been commissioned to create, he abandoned his original plan for the third, deciding instead to paint *To the Unknown British Soldier in France* 1921–8 (no.14). The flag-draped coffin aligning with the marbled architecture of the Palace achieves a symmetry in marked contrast to the chaotic scattering of the debris of war that almost obscures the burial in *A Grave in a Trench*, which he had painted in 1917. Yet *To the Unknown British Soldier in France* originally made direct reference to the experience of warfare through the inclusion of two spectre-like soldiers, naked and dead, flanking the coffin (fig.8). Its emblematic composition with cherubs above signalled the experience of remembering the war dead through their imagined presence. The official response to this painting considered it unacceptable, failing to appreciate that its precise purpose was to make visible a connection between postwar politics and the contribution and suffering of those who fought and died.[2] It was only in 1928, when Orpen removed the dead soldiers, that the Imperial War Museum agreed that it could join the two earlier paintings.[3]

This episode pinpoints several features of the ways in which the war was represented and remembered. It reveals the contrast between the visual documentation and material evidence of the experience of war and the images and objects later designed to commemorate it publically. It sheds light on the nature of private remembering and reflection and the way this shaped subjective expressions of loss, regret, tribute and despair by the bereaved, ex-servicemen and others.

Pervading both these is the way the remembered dead and the visibility of disabled veterans throughout the postwar period brought the past into the present in powerful ways. These characteristics can be identified in the work of artists from France, Britain and Germany, whether they had experienced the war through official commissions, as combatants themselves, or as witnesses of the conflict on civilian populations.

Artists responded to the First World War independently, or through opportunities awarded as part of formal recording initiatives and projects of commemoration. The need to construct permanent sites and objects of remembrance meant that sculptors and architects were in demand. The vast scale of loss created a need for markers that acknowledged it visually and spatially – on former battlefields, in cemeteries, as part of the fabric of the major towns and cities of each combatant nation, or more intimately within places of work, worship or home. Sculpture, having had a memorial function since ancient times, was understood as an established component of commemorative environments and remembrance activity. Even so, the practical and conceptual difficulty of commemorating losses that were imperial in reach and industrial in scale presented challenges for those who commissioned memorials, those who made them, and those who viewed them. In cities and large towns, the syntax of funerary or civic monumental forms was redeployed in new arrangements, but in such a way as to represent the many rather than the few. Sculptors and architects who were versed in the making of public statuary, or memorials to earlier wars, adapted their repertoire. In smaller communities, less elaborate and less costly memorials could be commissioned from local sculptors and architects or supplied by monumental masons or commercial suppliers of funerary objects.[4]

At a national level, the difficulty of commemorating hundreds of thousands of dead called for approaches that exceeded the possibilities of nineteenth-century monumental vocabulary and its precedents. Inevitably, the imperial capitals with their history of monumental embellishment were the focus of commemorative activity that sought to include populations near and far. The ancient concept of the cenotaph – an empty tomb – was resurrected to function as a modern mnemonic device in both temporary and permanent versions, and in celebratory as well as sombre contexts. A cenotaph served to denote all the dead of particular nations, including many thousands of colonial troops, and it was also reproduced and modified to represent the war dead from specific communities. The temporary structure designed by André Mare for the Fêtes de la Victoire in Paris, held on 14 July 1919, heralded the Whitehall Cenotaph in London, although Edwin Lutyens' version was devoid of embellishment and far more austere (nos.13–17). The enormous popularity of the ceremonies in 1920 that dedicated the Tomb of the Unknown Warrior in London

Fig.8
William Orpen
To the Unknown British Soldier in France 1923. Original version exhibited at the Royal Academy of Arts in 1923.
Imperial War Museum

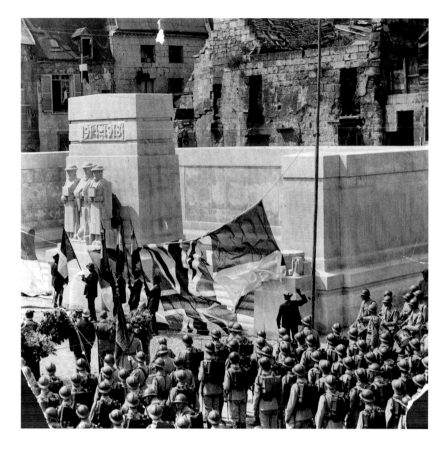

and *La Tombe du Soldat inconnu* in Paris demonstrated the desire for bodily evidence to literally flesh out, complement and to some extent moderate the conceptual challenge of the cenotaph's abstraction.

Established artists, largely painters, were called upon to record such commemorative ceremonies as national events. Frank Salisbury's *The Passing of the Unknown Warrior, 11 November 1920* 1920, suggests nothing of the experience of the spectators on these occasions (no.13). Empathising with – and, in turn, exploiting – their vulnerability are the photographic creations of Ada Deane, who conjured up the presence of the absent dead through exposures made for the duration of the two minutes' silence in 1922. Though we may find these images ridiculous, at the same time they elicit our sympathy with the bereaved attempting to see once again those lost to them. They show how technology could introduce new ways of seeing and be incorporated as a popular commemorative strategy alongside the conventional components of official activity.

Equally unsettling in the way it disrupts the visual language of the academicians is Stanley Spencer's *Unveiling Cookham War Memorial* 1922, whose odd perspective and puckered fallen flag creates the atmosphere of an uneasy crowd witnessing a disturbing event in different ways (no.24).

Those artists, like Spencer, who had experienced active service sometimes challenged expectations in the way they represented the war. Progressive members of commissioning committees supported and

championed those who dispensed with the representational language of the last century or with traditional ideas about military art. While the painters produced substantial works of art that could, and did, stand by themselves in museums and galleries, the young British sculptors Charles Sargeant Jagger and Gilbert Ledward, soon abandoned early raw depictions of battle that attempted to convey what they had witnessed. Jagger's *No Man's Land* 1919–20 is a horizontal line of horror strung with tangled wire, fragmented limbs and punctuated with abandoned kit and equipment (no.19). Jagger and Ledward were among the sculptors called on to create distinctive memorials for public contexts that placed emphasis on the monumental figure of the solider and put him securely back on his feet, helmet on head (or in hand), resolute in stance (no.20).[5] This development of a contemporary monumental idiom, the best examples characterised by architectonic forms and stoic rather than heroic, took place alongside a more pressing design problem enormous in its scale: how to deal with the actual logistics and commemoration of mass death on the battlefields not just in Europe but in the other theatres of war. The vast national and imperial infrastructures that served both to build and maintain cemeteries and to connect them in a unified way that was territorial as much as memorial involved architects and artists in both their planning and execution. In Britain, the Imperial War Graves Commission was established in 1917 to maintain graves, identify the missing, and to build a physical network of sites that was designed to deliver a coherent and readily understood story about loss and grief – but also, through its occupation of landscape by way of the bodies of the dead, imperial reach and its power. In Germany, the Volksbund Deutsche Kriegsgräberfürsorge was established in 1919 to coordinate the care of German graves, the majority of which were in other countries; around fifty per cent of the 1,937,000 German war dead were killed in France, and the graves and memorials erected to them were left behind as the Allied offensive advanced (fig.10).

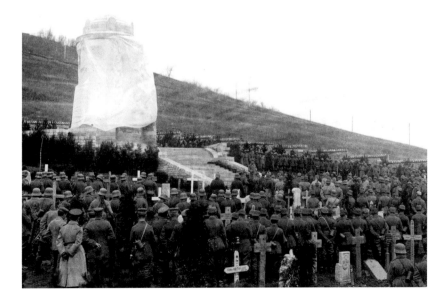

Fig.10
The unveiling of a memorial to dead German troops at Sedan c.1917–18.
Imperial War Museum, London

The British design plan, while allowing for some modification depending on scale and context, stressed overall uniformity. This was achieved by repeating cemetery components in different arrangements, from large architectural elements such as Reginald Blomfield's *Cross of Sacrifice* 1918 and Lutyens' *Stone of Remembrance* 1917 to the distinctive headstones and the precise specification of inscription style and syntax. In contrast, the architect Robert Tischier argued that the cemeteries of the German dead should blend with local landscapes rather than adhere to one overarching pattern. The theme was collaborative remembrance negotiated with other countries rather than a visual and physical stamp of occupation which was, in defeat, out of the question anyway.[6] The French employed different forms and mapped commemoration on destruction. The ruins and desolation in themselves were totemic of the damage of warfare, and became unintentional monuments, as did the 'iron harvest' that was thrown up as farmers sought to return the land to its former productivity. At Douaumont, an ossuary was constructed to contain bones, belonging to both French and German soldiers, rendered unidentifiable by fragmentation and sheer quantity. In Paris, as well as the *Tombe du Soldat inconnu* under the Arc de Triomphe, a memorial to all the unknown was later erected inside the Panthéon; it depicted a recumbent soldier, face turned away, with female figures representing *Memoria* and *Gloria* standing above.

At a local rather than national level, the scale and parameters of commemorative objects sought to record loss by naming those who died (and in Britain sometimes those who served) from particular communities. The *monuments aux morts* that can be found across France, the *Ehrenmal* in Germany and the war memorials on village greens and town squares across Britain epitomise this community-specific remembrance and its human scale. During the war temporary shrines, framed rolls of honour listing those serving and other structures were assembled by some localities as a way of marking those who had gone from them. In Germany, the collective and incremental nailing of wooden objects created *Nagelfiguren*, symbolic markers of communal commitment and resolve (no.26).[7] As the death toll accumulated permanent memorials were discussed and some began to appear even before the Armistice. They continued to be erected throughout the 1920s, with some elaborate commissions taking even longer. As well as the architectural forms of obelisks, crosses, steles and columns, statues of soldiers that stood in for the absent dead (and often idealised them) were popular, as were allegorical figures representing Peace, Victory, *La France* and so on. Less frequently, statuary represented mourners or the next generation, and sometimes occupied the lower pedestal of a large monument, or bridged the spectator's space to achieve a link between those commemorated and those remaining. At Ailly-sur-Noye on the Somme, the *monument aux morts* is actually surmounted by a mourning woman. Made by the sculptor Auguste Carvin (1868–1949), she wears regional dress, and with head bent holds a *poilu*'s helmet in her arms (fig.11).

The sheer variety of strategies adopted for local memorials, and also the repetition of popular types, ranged from the didactic to the

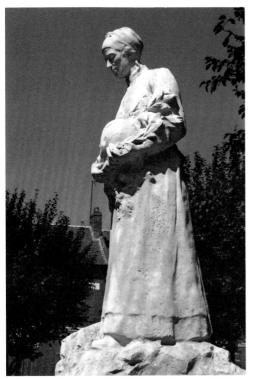

affective, and varied in quality from the accomplished to the crude. In Germany, as in France and Britain, cultural organisations and government at various levels sought to offer advice and vet design proposals. Yet it is the names carved or painted on these supports that make each object particular, and its location that gives it context. Flags, marching, music and the repeated choreography of unveilings and annual Armistice Day or veterans' ceremonies became established elements of memorial environments as the years passed. Very occasionally, memorials would become sites of protest, while in Germany the legacy of the war dead would come to be enmeshed in Nazi ideology, removed from the realm of local mourning to national glorification. Those memorials that did not serve this new function were deemed unacceptable. Ernst Barlach's *The Floating One* 1927 (no.23), like Wilhelm Lehmbruck's *The Fallen Man* (no.1) ten years earlier, both refute the monumental in their horizontal alignment: crawling and flying, they contest the militarised body and its aggression, the ideal body and its inherited rhetoric. For this reason they would come to be considered 'degenerate'. So too was Käthe Kollwitz's sculpture (no.22), which achieves its power through its entire focus on the persistence of grief, with grief itself being the subject rather than the effect of the work.

William Orpen's *Blown Up* 1917 powerfully conveys the vulnerability of the body and the psychological damage of war (no.28). It was this figure, doubled and placed alongside the coffin in his third Peace Treaty painting that the authorities who rejected the work considered out of place. Yet the damaged and disabled were visible within the communities to which they returned and they were included in commemorative ceremonies, local and national. Living evidence of the impact of war, in hospitals or on the street, those with lost limbs or sight, disfigured or psychologically damaged, reminded others of the price of conflict and the fiction of completeness relayed by figurative sculpture in public places.

In this dynamic context of postwar contradictions – social, technological and cultural – most conventional memorials were soon, if not immediately, anachronistic. Souvenirs and mementoes from the war years, including objects made or used by serving soldiers, retained their aura and gained symbolic status. Some were depicted on war memorials, but the captured gun, dented helmet and dog tag possessed an authenticity that exposed the conceit of representation. These objects achieved symbolic power through their ubiquity and relic status in their particularity. They encapsulated the contradictions of war, industrial yet bestial, and a catastrophe that was global as well as personal. Medals, too, although mass-produced were micro-sculptures indicative of personal experience since they were attached, literally, to individuals. They were worn by veterans and also by bereaved women and children. Returned crosses from the battlefield, other possessions and portrait photographs were mourned over. During the war, in 1917,

Fig.11
Auguste Carvin
Monument to the Dead,
Ailly-Sur-Noye, France,
1922

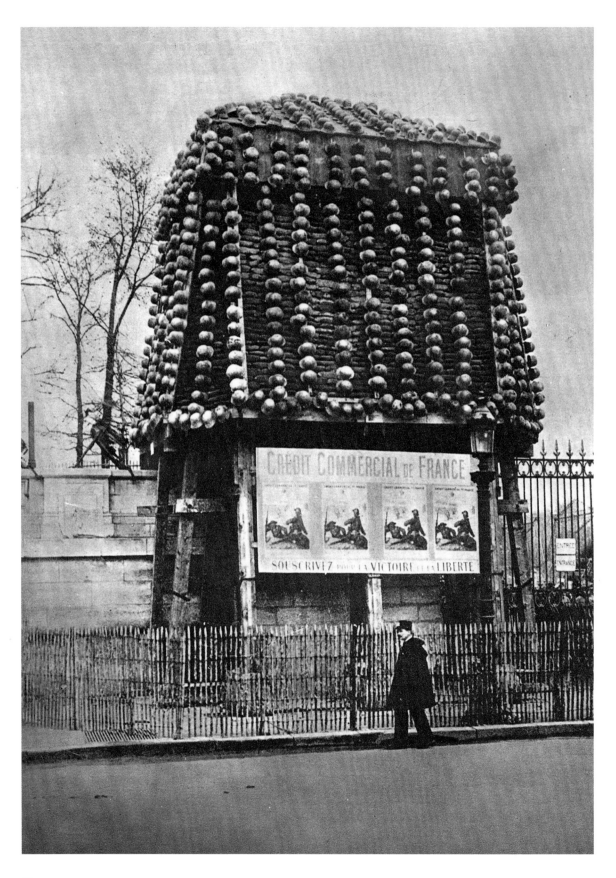

the Director General designate of what would become the Imperial War Museum argued that emphasis on the memorial function of the museum's collections would ensure it was more popular as a form of commemoration than any 'pile of sculpture'.[8]

In his 1922 novel *Aaron's Rod*, D.H. Lawrence describes the post-Armistice atmosphere in a Midlands mining town: 'there was a sense of relief that was almost a new menace. A man felt the violence of the nightmare released now into the general air'.[9] Monumental forms from the local to the imperial sought to create closure and order, but artists were already exploring ways to express with more authenticity the dilemmas and frictions of a postwar present with its burden of the recent past. In 1933, the playwright Laurence Stallings who had served with the US forces in France, and himself an amputee, compiled a 'photographic chronicle' depicting the war from the experience of all combatant nations.[10] The captions, juxtapositions and sequencing expose the iniquities, sufferings, and waste in a manner similar to Ernst Friedrich's *Krieg dem Kriege!* (*War Against War!*) of 1924 (no.38). Included in this remarkable publication is a photograph of a monument in Paris during the war. Hidden by protective boards and sandbags, it assumes a form similar to a cenotaph (fig.12). Above a line of posters promoting war savings, the entire surface of the superstructure is decorated with captured German helmets. Stallings recognised that this inadvertent memorial, with its nod to ancient trophies yet its startlingly modern form, spoke a particular truth. He captioned it 'Idol'. CM

1 W. Orpen, R. Upstone, & A. Weight, *William Orpen: An Onlooker in France. A Critical Edition of the Artist's War Memoirs*, London 2008, p.224.

2 Ibid. pp.39–44.

3 Of course, the presence of the coffin at Versailles is entirely fictitious. Coffins from the main areas of battle, each containing a British soldier, were taken first to the chapel of Saint-Pol-sur-Ternoise near Arras on 7 November 1920. The body selected was then sealed in a new coffin which was transferred to the castle at Boulogne before its journey by ship and railway to London for burial at Westminster Abbey on the 11th.

4 Daniel J. Sherman, 'Art, Commerce, and The Production of Memory in France in World War 1' in John R. Gillis (ed.), *Commemorations: The Politics of National Identity*, Princeton NJ 1994, pp.186–211.

5 Ann Compton (ed.), *Charles Sargeant Jagger: War and Peace Sculpture*, London 1986

6 Christian Fuhrmeister, 'Robert Tischler, Chefarchitekt 1926–1959: Ein Desiderat', *RIHA Journal*, 27 June 2017, Paper 0159. URL: http://www.riha-journal.org/articles/2017/0150-0176-special-issue-war-graves/0159-fuhrmeister

7 Susanne Brandt, 'Nagelfiguren: Nailing Patriotism in Germany 1914–18' in Nicholas J. Saunders (ed.), *Matters of Conflict: Material Culture, Memory and the First World War*, London 2004, pp.62–71.

8 Quoted in P. Cornish, '"Sacred relics": Objects in the Imperial War Museum 1917–1939', in Saunders 2004, p.41.

9 D.H. Lawrence, *Aaron's Rod*, Harmondsworth 1968, p.11.

10 Laurence Stallings, *The First World War. A Photographic History*, London, 1933.

Remembrance

1

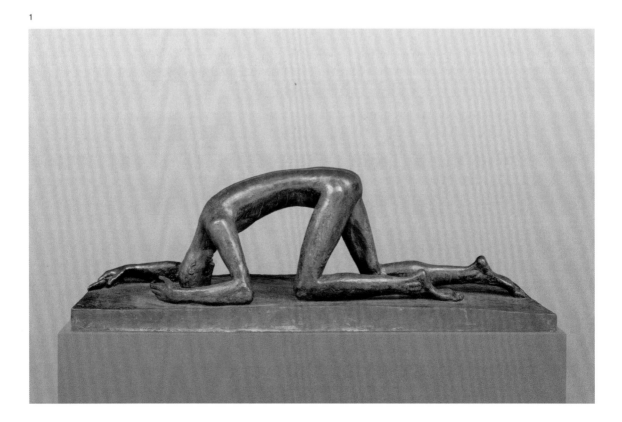

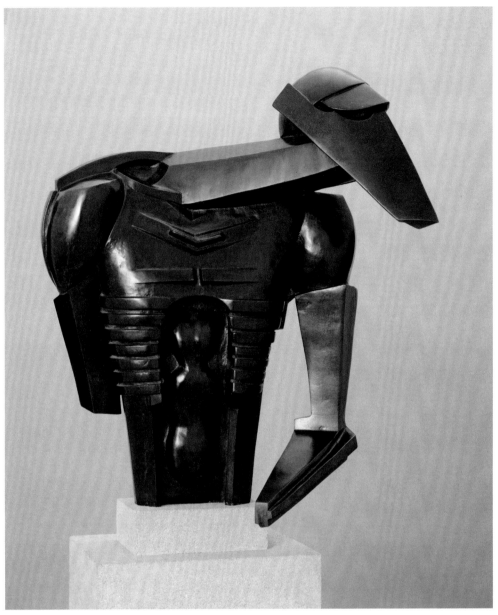

2

1
Wilhelm Lehmbruck
The Fallen Man 1915, cast 1916
Bronze

2
Jacob Epstein
Torso in Metal from
'The Rock Drill' 1913–4
Bronze

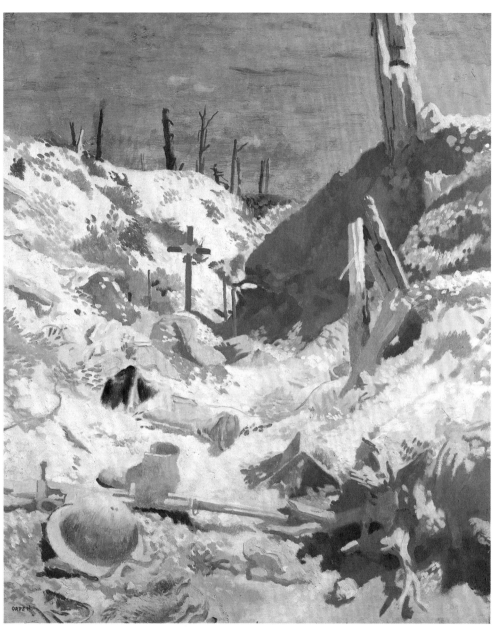

3

3
William Orpen
A Grave in a Trench 1917
Oil paint on canvas

4
Paul Nash
Wire 1918–19
Watercolour, chalk
and ink on paper

5
Paul Segieth
*Fort Douaumont under
French Fire* c.1916–18
Oil paint on canvas

24

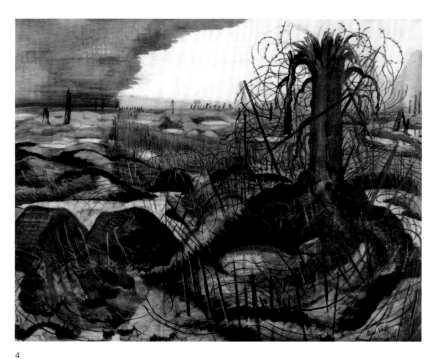

4

5

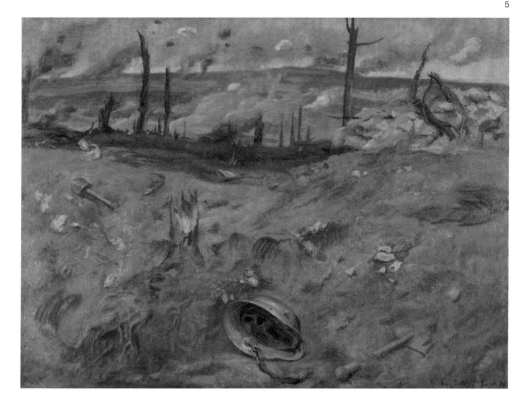

6
Paul Jouve
*Grave of a Serbian soldier
at Kenali 1917* 1917
Chinese ink, gouache and
graphite on paper

7
C.R.W. Nevinson
Paths of Glory 1917
Oil paint on canvas

8
Félix Vallotton
*Military Cemetery at
Châlons-sur-Marne* 1917
Oil paint on canvas

6

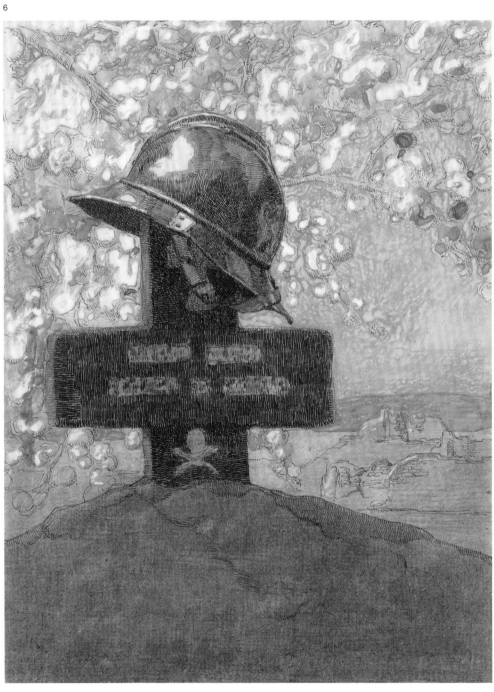

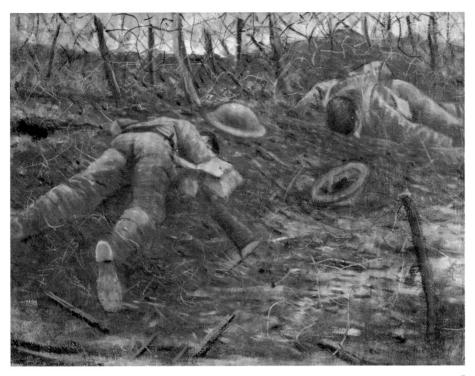

7

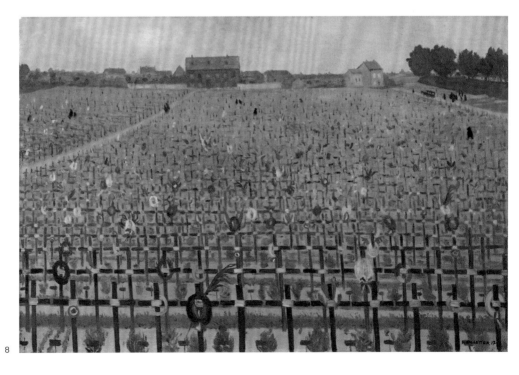

8

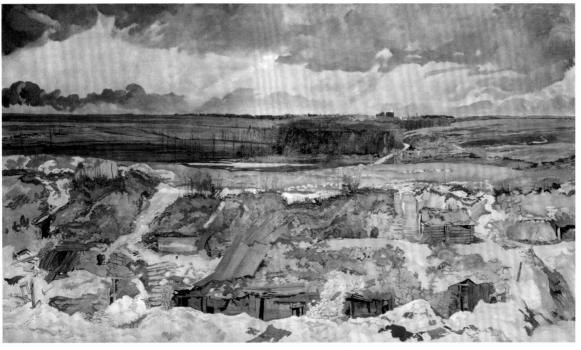

9

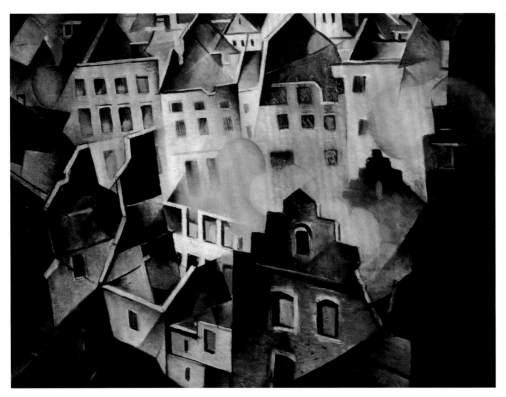

10

9
Charles Sims
*The Old German Front Line,
Arras, 1916* 1919
Oil paint on canvas

10
C.R.W. Nevinson
*Ypres After the First
Bombardment* 1916
Oil paint on canvas

11
Richard Carline
*Mine Craters at Albert Seen
from an Aeroplane* 1918
Oil paint on canvas

12
William Roberts
A Shell Dump, France 1918
Oil paint on canvas

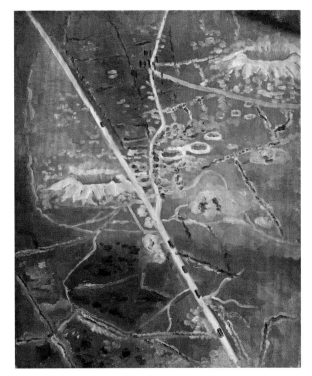

11

12

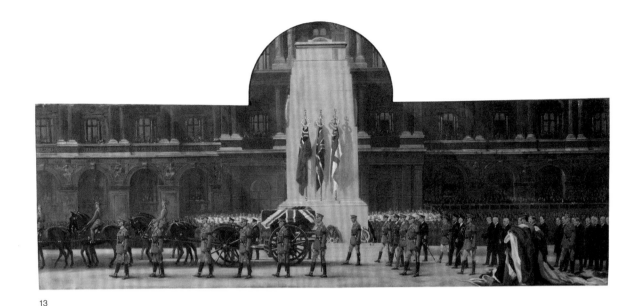

13

13
Frank Owen Salisbury
*The Passing of
the Unknown Warrior,
11 November 1920* 1920
Oil paint on canvas

14
William Orpen
*To the Unknown British
Soldier in France* 1921–8
Oil paint on canvas

30

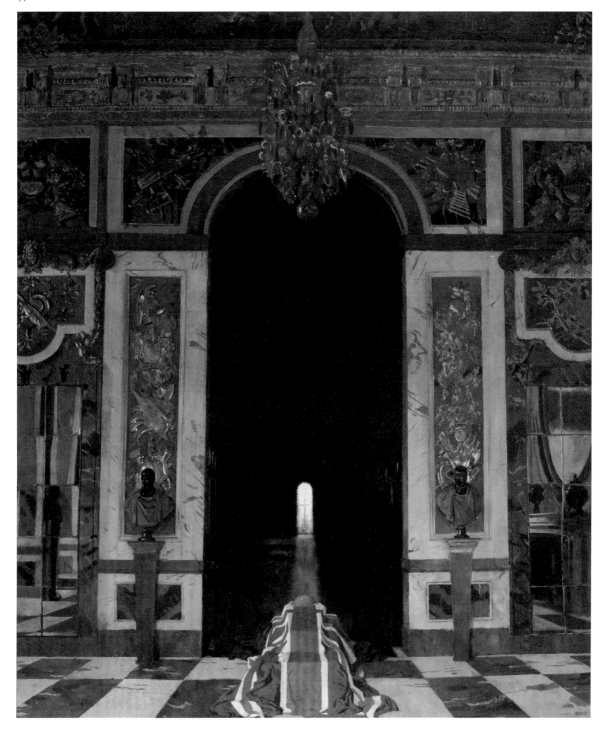

15
André Mare
*Decorative Scheme for
the Victory Celebrations
14 July 1919* 1919
Crayon on tracing paper

16
Anonymous
*Victory Celebrations in
Paris, 14 July 1919.
Monument to the Nation's
Dead* 1919
Postcard

17
Antoine Bourdelle
France 1923, cast 1977
Bronze

15 16

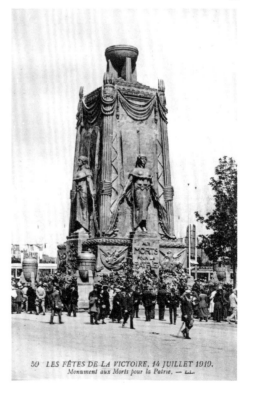

59 *LES FÊTES DE LA VICTOIRE, 14 JUILLET 1919.*
Monument aux Morts pour la Patrie. —

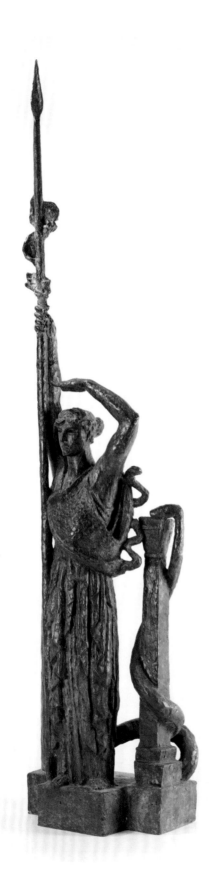

18
East Side of Royal Artillery
Memorial 1921–5
Hyde Park Corner, London

19
Charles Sargeant Jagger
No Man's Land 1919–20
(detail)
Bronze

20
Charles Sargeant Jagger
Driver 1921–5
Bronze

18

19

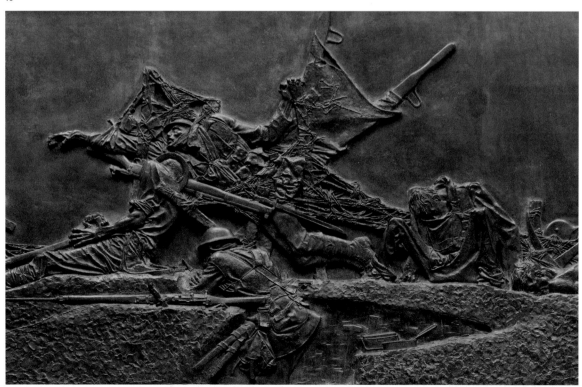

34

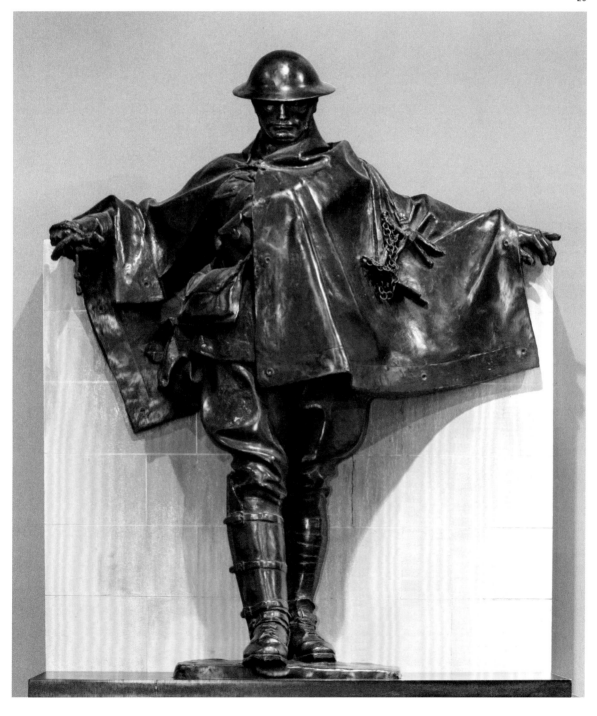

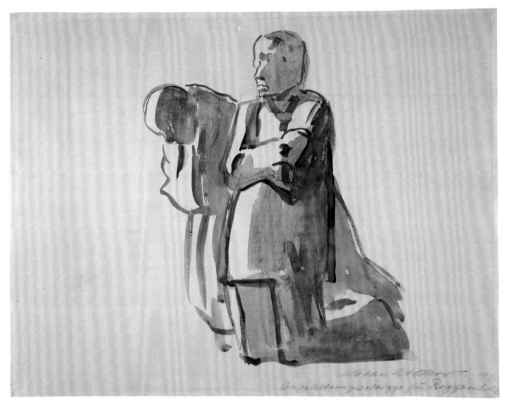

21

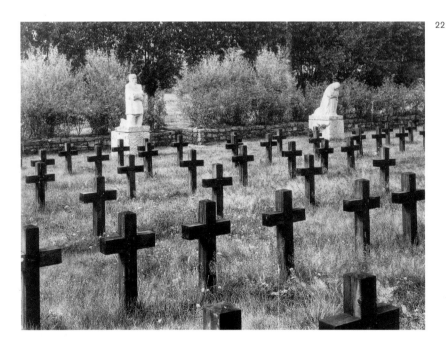

22

21
Käthe Kollwitz
*Design for 'The Parents'
monument, Roggeveld
military cemetery,
Belgium* 1927
Ink on paper

22
Käthe Kollwitz
*'The Parents' monument,
Roggeveld military
cemetery, Belgium*

23
Ernst Barlach
The Floating One 1927,
cast 1987
Bronze

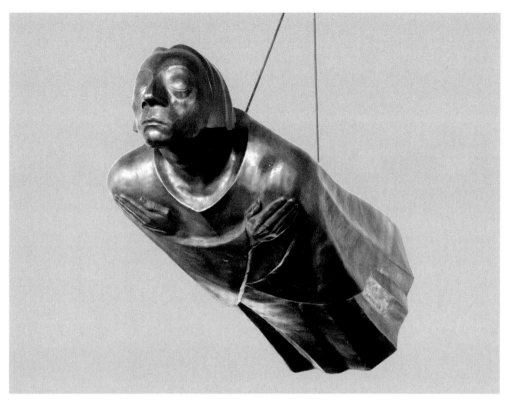

23a

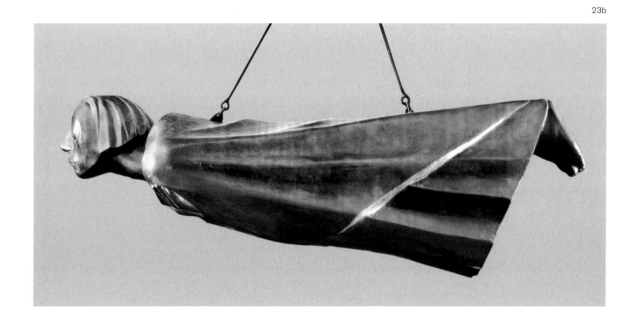

23b

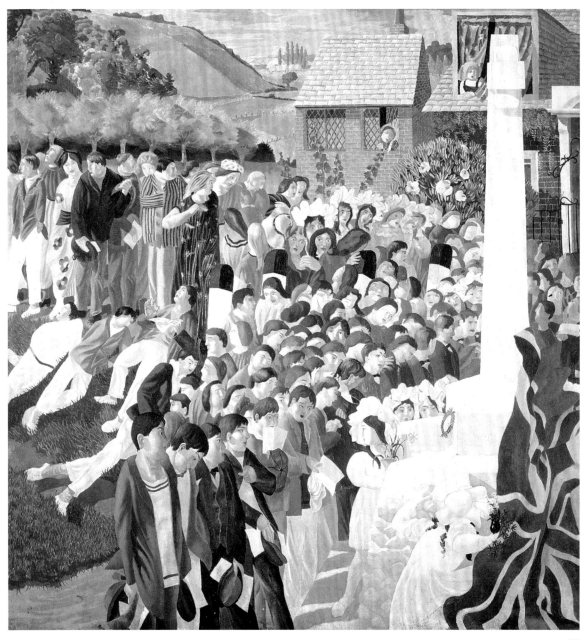

24

24
Stanley Spencer
*Unveiling Cookham War
Memorial* 1922
Oil paint on canvas

25
Marcel Gromaire
War 1925
Oil paint on canvas

26
Nail Object 1914–18 1918
Painted wood and nails

27a
*British, French and
German tanks*
Shell case metal

27b
*German Memorial
Bullet*

27c
*Selection of inscribed
Scimitars*

27a

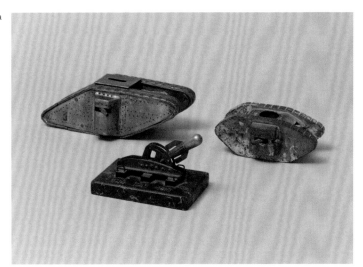

27b

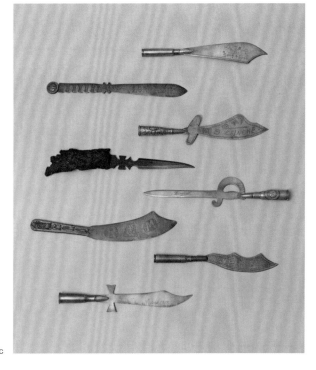

27c

Here Everything Is Still Floating

by Michael White

In the extraordinary text that accompanied the extraordinary object that the erstwhile Oberdada Johannes Baader exhibited at the *First International Dada Fair* in Berlin in 1920, the artist wrote scathingly of the role of the press during the First World War. In terms prescient of the French philosopher Jean Baudrillard, he asserted that

The World War is a war of newspapers. In reality it never existed … It's all hogwash, from the first reports of mobilisation, to Liège, the Battle of the Marne, the retreat from Russia and the armistice. The press created the war. The Oberdada will end it.[1]

Any number of things in this statement are startling but I will pick out just a couple. The first is the extent to which an avant-garde artist known primarily for the creation of absurdist works was so closely engaged with war and its documentation. The second is summed up in the final sentence. 'The Oberdada will end it.' Surely it, the war, had ended two years before? By returning to the fictions of wartime journalism, Baader was contesting their continued power in the postwar period. The war might have ended on the battlefields but its meaning and significance were still to be fought out in the public realm. If the war was over as a physical fact, as a psychological one it was certainly not.

The object that Baader's text accompanied, the *Great Plasto-Dio-Dada-Drama* 1920 was a large pile of ephemera that did not survive the exhibition. Fortunately it is documented in two photographs, which reveal that, despite its apparent unruliness, it had a clear spiral structure linked closely to Baader's text (fig.13). The comment about newspapers was connected to the fourth level of what Baader also described as a piece of 'Dadaist Monumental Architecture in 5 Storeys' – a level dedicated to the war. Adjacent to the large number 4 was a collection of newspapers. The headline of one at the forefront reads, 'An English-French Advance South of Beles Repelled,' referring to an Allied assault on the Salonika Front north of Macedonia, part of the supposedly impregnable Balkan terrain that Allied forces eventually broke through in 1918.

The spiral form of Baader's outlandish counter-monument parodies such glorious precedents as Trajan's Column, constructed to celebrate the Roman emperor's Dacian campaign, a military victory in precisely the same Balkan region. In Baader's case, though, the end point, marked by the number 5, brings us not to glory but to the title of the radical journal *Die Pleite* ('Bankruptcy') and a toy train carriage representing the site where the armistice was signed in November 1918. The *Great Plasto-Dio-Dada-Drama* as a whole is presented to us by a mannequin stand-in for Baader, with the ironic legend *Dada siegt* (Dada Conquers) glued to its forehead. Dada continued fighting a culture war long after the big guns fell silent.

That Baader may have had ancient, and indeed more recent, memorials in mind when creating this work is not surprising given that he had in earlier life practised as an architect with a speciality in funerary monuments. Long unrecognised in accounts of the practices of the post-First World War avant-gardes is the continued presence of conventional iconographies of commemoration in even the most formally radical works. The debates between historians that have split between modernists and traditionalists – between those who see the war as having a totally transformative effect that cleared the way for a new world and a new person to occupy it, and those who see it as provoking a return to the past and a search for solace in the familiar – have overshadowed consideration of these features.

In a major attempt to step beyond the intellectual impasse that has played past off against future, the historian Jay Winter has proposed that we consider how the artistic legacy of the First World War was shaped by the demands of public and private grief, and 'the power of traditional languages, rituals, and forms to mediate bereavement'.[2]

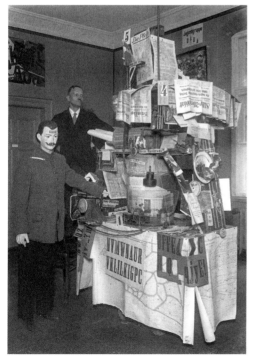

Fig. 13
Willy Römer
Dadaist Exhibition in Berlin,
1920

Winter's approach is powerful and moving but unfortunately also continues to hold the extreme responses of someone like Baader at arm's length from debates about the war's ultimate significance. As Winter continues: 'Irony's cutting edge – the savage wit of Dada or surrealism, for example – could express anger and despair, and did so in enduring ways; but it could not heal.'[3] As we have seen, Baader was not ready simply to give up his recent memories and move on. Baader's alter-ego mannequin, whose consciousness has been claimed by the slogan 'Dada conquers', is one of many instances of paralysed or frozen figures for whom normal actions had become impossible. Nevertheless, the very refusal to move on could have dramatic political significance.

'Sir, why are you standing there?' – The man remains standing. 'Sir, what are you standing there for?' – The man stands. 'Sir, why are you standing there?' – The man stands. 'Sir, just why are you standing there?' – The man stands. 'Sir, how come, that you are standing there?' – The man stands.[4]

And so on, and so on continues Kurt Schwitters' *Revolution in Revon* (1922) – until the story's end, when, shockingly, the standing man 'slowly, and with the tranquillity of a perfect machine, left'.[5] 'Just as the powder magazine is exploded by a spark', so this most minimal of movements provokes chaos in the fictive city of Revon: a riot ensues that leaves several people dead.[6]

The image of the standing man has to date been primarily considered an analogy for the artist himself. It is, according to John Elderfield, 'clearly a fanciful self-portrait of the apolitical artist attacked by critics and social agitators – the withdrawn artist, misunderstood by the inhabitants of bourgeois, no-nonsense Hannover'.[7] The standing man is at one point identified by name. He is Franz Müller ('Francis Dustcarter' in the English translation), a regular character in Schwitters' texts and art works. Named after the German for rubbish, *Müll*, he shares his creator's attraction to detritus, the waste products out of which the artist made so many of his artworks. Schwitters described Müller's clothing as 'very curious … not plugged or mended, but nailed with planks and surrounded with wire', evoking some of the materials of the camp and battlefield.[8] That made him into 'a perambulating *Merzplastik* (Merz sculpture],' a living work of art by Schwitters, who had since 1919 been giving all of his artistic production the imprimatur of the nonsense word *Merz*.

The most celebrated *Merz* work of all was Schwitters' transformation of a number of rooms in his family home into an ever-growing art work known as the *Merzbau* (Merz Building). Destroyed by British bombing during the Second World War, the *Merzbau* is represented today by a small number of photographs and several anecdotes. Its later unprecedented architectural scale conceals the fact that it began in more recognisable form as a column (fig.14). Though assembled from all kinds of non-artistic materials (such as children's toys, domestic fittings, plants and printed ephemera), the column is clearly divided into the usual three parts of its architectural forebear: base, shaft and capital. At the bottom are items that relate to *Merz* and its origins in the circulation of avant-garde journals, including one of Schwitters' very first collages. The shaft is made up of a broader assortment of figurines and three-dimensional objects, with the very top crowned by a child's face. There are any number of victory columns in Germany and elsewhere with equivalent structures; one very similar object exists in Schwitters' home city, erected in remembrance to the Hannoverian contribution to the defeat of Napoleon at Waterloo. What looks like a doll's head on top of the *Merz-column* is no such thing at all, though. It is, in fact, the death mask of Schwitters' first-born child, Gerd, who died just a week after his birth in 1916. While the column was to gradually disappear into the expanding structure of the *Merzbau*, Gerd's face remained ever visible. The *Merz-column*, as Dorothea Dietrich put it, is 'no longer a victory column but a funereal monument'.[9]

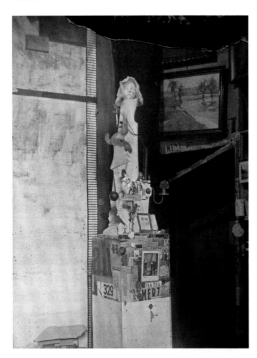

Fig.14
Kurt Schwitters
Untitled (Merz Column)
1923–5, Mixed media,
Destroyed 1943.
Kurt Schwitters Archives
at the Sprengel Museum
Hanover

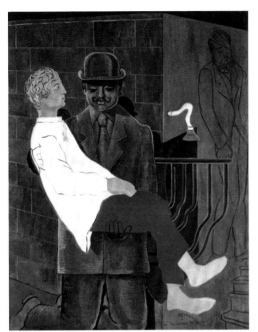

Schwitters' response to loss, marked by his incessant accumulation of materials and their incorporation into this giant artwork, is more pathological than the kinds of memorials and rituals that Winter found prevalent in European culture after the First World War, but it is not without comparison. According to Schwitters' description, by 1931 the *Merzbau* had its own lighting system to illuminate a series of grottoes dedicated to certain people or themes, including both grand historical figures such as Goethe and more disturbing topics, such as the 'Cave of Sex Murder'. There was also a 'brothel with a three-legged woman' and a grotto for the '10% war wounded.' As Dietrich has further observed: 'by using the fragments of his life as the building stones for his column, (Schwitters] prevented these fragments from turning into anonymous shards'.[10]

This had far more to do with the war than is often recognised, as can be seen from an overlooked text that Schwitters published in his magazine *Merz* in the same year the *Merz-column* was created. Titled 'War', it declares that 'This is just the time, just as we are in the midst of deepest peace, to prevent a war.'[11] The means of prevention, for Schwitters, was to overcome nationalist sentiment by encouraging the feeling the 'we are all members of a great nation, that of humanity … Build ladders and climb to the roof of the moon but leave people's rooves undamaged. That is world patriotism.'[12] As for Baader, the war was very much unfinished business for Schwitters and his contestation of its legacy was connected to his pacifist principles.

Although both men were conscripted, neither Schwitters nor Baader saw frontline action in the First World War. Baader, already forty and with a history of mental illness, was posted to Belgium where he spent most of his time patrolling. Schwitters, who suffered from epilepsy, spent his time on clerical duties and as a draughtsman. A different experience was had by the artist Max Ernst, who spent all four years of the war on active service, mainly on the Western Front. A similar sense of the war's inconclusiveness is not to be found in his blank summarisation of those years: '(1914) Max Ernst died the 1st of August 1914. He resuscitated the 11th of November 1918 as a young man aspiring to be become a magician and to find the myth of his time.'[13] This would seem to be more reflective of the modernist position articulated above: Ernst had been 'reborn' after the war, with a new artistic mission. In a self-portrait image of 1923, Ernst used the Christ analogy suggested in his statement rather differently, though, deploying the iconography of the *Pietà* to present himself not as the risen but as the dead Christ (fig.15). Ironic though this image may be, as it scandalously replaces the grieving Madonna with an impassive father figure, it significantly shows Ernst in a between state: stuck, immobile and statue-like. He is neither dead nor alive, not regenerated as his later autobiographical comment proposed.

Significantly, the war quite literally did not end for Ernst on his demobilisation. He returned to his home city of Cologne only to find it under military occupation. British forces took control of the city in December 1918 and ran it under martial law. Some of the oddity of Ernst's dada works derives from his resistance to forms of censorship and the artistic scrutiny imposed by the British military government. Some works also record Ernst's frustration at the restrictions imposed on his movement, particularly his desire to get to Paris, which he finally did in 1922, illegally, after failed attempts to secure a travel visa.[14]

In 1920, Ernst participated in Tristan Tzara's grand postal project *Dadaglobe*, an attempt to make a compendium marking dada's dissemination across borders, among nations that had recently been at war with each other. Ernst sent Tzara a number of 'Fatagagas,' his name for strange photomontages he had begun making in collaboration with his old friend and fellow dadaist, Hans Arp. One of these was accompanied by a complex caption, which translates as:

Here everything is still floating. It is not yet 2 o'clock. No one was still thinking about the 2 ferdinis with their flying clubs and hats (still in top form). Here the armada is definitely defeated for the first time. The rainbow eater didn't know. The gut steamer and the skeleton fish decided to take off.

This ridiculous text matches an eerie image of two objects, one a ship-like form (actually an inverted beetle), the other the insides of a fish. They hover in an abstract space, blank except for a few peculiar cloud formations (no.39). In fact, the source for this background is a photograph from a German book on military aviation showing an 'English attack with chemical gas bombs from airplanes'.[15]

While not really a description of it, Arp's text is rich in association with the wartime image. 'Floating' in the first sentence is the phrase *in der Schwebe*, which also has the senses of 'in the balance' or 'not yet clear.' We are waiting for something to happen, perhaps at 2 o'clock. The idea that 'something might be up' is repeated in the mysterious '2 ferdinis' with their flying clubs, *Keulen* in the German, which could result in a *Keulenschlag*, figuratively a surprise, like a thunderbolt.[16] They are not just 'in top form' but *auf der höhe*, 'up high'. *Keulen*, very significantly, also happens to be the Dutch name for Cologne. An aerial attack on Cologne? 'Armada' references both an invading force and Ernst's wife Luise Straus, who used the artistic name Armada von Duldgedalzen, while the 'gut steamer,' the *darmdampfer*, encodes the two syllables da-da. While none of this actually makes any sense, it evokes the aura of a hidden message, just as the aerial photo has been disguised, as if to be secretly passed on, across a border Ernst was not able yet to physically cross.

The prevalence of references to wartime communication and experience in dada works has been greatly underappreciated over the years, and extends even to objects where post-war politics seems to be the most pressing concern. The *First International Dada Fair* was a great stimulus to Ernst to experiment with photomontage. One of the exhibition's key contributors and practitioners of photomontage was

Fig.16
Military souvenir, 1897/9.
Engraving, coloured and
collaged, 42.5 × 51.7. Labelled by
Hannah Höch *Der Anfan(g)
der Fotomontage (The Beginning
of Photomontage)*. Hannah Höch
Archive, Berlinische Galerie.

Hannah Höch, whose contributions have been mainly noted for their
commentary on the transformed, postwar situation for women.
Her photomontage *Dada Rundschau* (*Dada Panorama*) of 1919 (no.45)
contains a number of images relating to the entry of women into
German political life that year, marked by the introduction of women's
right to vote and to hold elected office. A group of women in the top
left are almost literally striding into the *Nationalversammlung*, the
parliament; in the bottom right, the artist signs with her initials and
claims 'unrestricted freedom' (*schrankenlose Freiheit*).

A key person in the montage is to be found just to the centre left,
though, where we see the face of the German Vice-Chancellor, Matthias
Erzberger. He was the unfortunate person to have signed the armistice in
1918 on behalf of Germany, an act that earned him the reputation among
far right groups of national traitor and led to his assassination in 1921. Out
of his head rises the message 'All conditions complied with', suggesting
exactly the idea of acquiescence with which his reputation was tarnished.

Once Erzberger's position in the montage is noted, further
references to the war and its legacy begin to emerge. The word *Dada*
and year 1919 on the right is balanced on the left by the year 1914 and
the word *Vivatbänder*: these were commemorative silk ribbons bearing
patriotic mottos very commonly worn during the war. The celebration
of women's suffrage that the montage commemorates is balanced by
a mocking of wartime slogans, such as the comical *Gegen feuchte Füße*
(Against Wet Feet), identifying a new enemy to be tackled. At bottom
left we see a parade group of soldiers labelled the *Studentenrat* (Student
Council), although their heads have been jokingly replaced by those of
older men, mimicking the long-established oleograph military souvenirs
that Höch later recalled as a key influence on photomontage, where

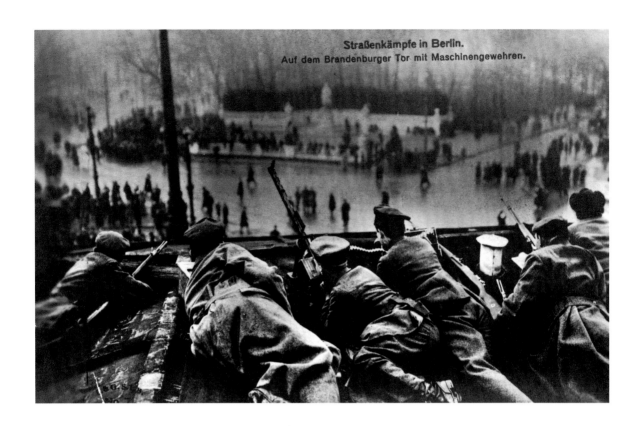

Straßenkämpfe in Berlin.
Auf dem Brandenburger Tor mit Maschinengewehren.

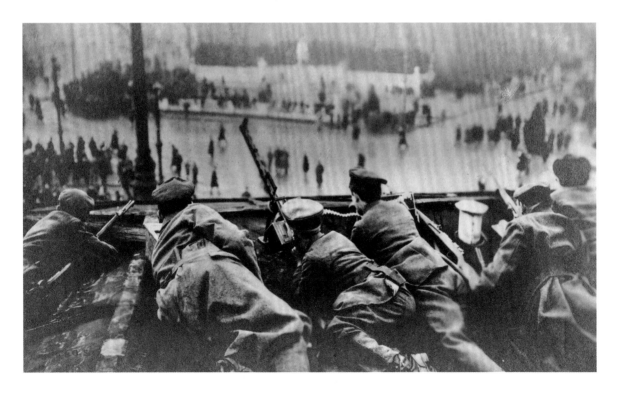

Fig. 17a (above) and Fig.17b (below)
Two identical photos dated 1919
showing soldiers on the
Brandenburg Gate, one referring
to them as Spartacists, the other
as government forces.

individual faces were printed onto stock images to represent one's time in service (fig.16). Their by-then outdated leather *Pickelhaube* spiked helmets contrast with the less glamorous attire of the soldier who faces them on the right.

That developing sense of dual structure to the montage – left and right denoting before and after, war and postwar, 1914 and 1919 – is disturbed both by the women entering top left and also, importantly, by that soldier in the lower right. His image is taken from a photograph of a sniper positioned on top of the Brandenburg Gate during street-fighting between revolutionary and government forces in Berlin in January 1919 (fig.17a). The soldier's prone position makes him both dangerous and harmless simultaneously: he is active, sniping, but also, like many of our other cases, inactive. He surveils the scene from above but is actually crawling at the bottom of the image in a decidedly non-heroic, almost dead pose. Whether we are looking at a member of the soldiers' council taking part in the uprising or the volunteer regiments the new Weimar government enlisted to suppress them is made decidedly unclear. Uniformed soldiers took part on both sides and such photographs as these were frequently later repurposed for right-wing, anti-communist propaganda (fig.17b).[17] The Oberdada was to some extent correct, then. The war continued, at least in the battle of images and struggle for memory. But try as he might, he and his fellow dadaists were not able to end it. **MW**

1 Johannes Baader, 'Deutschlands Größe und Untergang,' in Richard Huelsenbeck (ed.), *Dada Almanach*, Berlin 1920, pp.94–5.

2 Jay Winter, *Sites of Memory, Sites of Mourning: The Great War in European Cultural History*, Cambridge: 1998, p.115.

3 Ibid.

4 Kurt Schwitters, 'Revolution: Causes and Outbreak of the Great and Glorious Revolution in Revon', *Transition*, no.8, Nov. 1927, p.64.

5 Ibid., p.75.

6 Ibid.

7 John Elderfield, *Kurt Schwitters*, London 1985, p.103.

8 Schwitters 1927, p.71.

9 Dorothea Dietrich, 'The Fragment Reframed: Kurt Schwitters' "Merz-column"', *Assemblage*, no.14, April 1991, p.89.

10 Ibid.

11 Kurt Schwitters, 'Krieg,' *Merz 2*, April 1923, p.22.

12 Ibid.

13 Max Ernst, 'Some Data on the Youth of M.E. as told by himself', in Max Ernst, *Beyond Painting: And Other Writings by the Artist and his Friends*, New York 1948, p.29.

14 For a good account of Ernst's pining for Paris, see the description of his 'Farewell My Beautiful Land of Marie Laurencin' (1920) in Anne Umland and Adrian Sudhalter (eds.), *Dada in the Collection of the Museum of Modern Art*, New York 2008, pp.136–40.

15 For this identification, see Ibid., p.157. The first identification of Ernst's sources was made by Ludger Derenthal, 'Wie Max Ernst den Ersten Weltkrieg in seine Fotocollagen klebte,' in Karl Riha and Jörgen Schäfer (eds.), *Fatagaga-Dada: Max Ernst, Johannes Baargeld under der Kölner Dadaismus*, Gießen 1995, pp.48–58.

16 *Keulen* has been translated elsewhere as 'hams,' after the meat joint they resemble, which I think misses this more significant meaning. See William A. Camfield, *Max Ernst: Dada and the Dawn of Surrealism*, Munich 1993, p.85.

17 See Thomas Friedrich, 'Das "Revolutions-trauma" der Nationalsozialisten und der Umgang der NS-Bildpropaganda mit den Fotos der Novemberrevolution', in Andreas Hallen and Diethart Krebs (eds.), *Revolution und Fotografie: Berlin 1918/19*, Berlin 1989, pp.227–40.

Traces of War

28

29
Henry Tonks
Private Charles Deeks 1916
Pastel on paper

30
Henry Tonks
Private Charles Deeks 1917
Pastel on paper

29

30

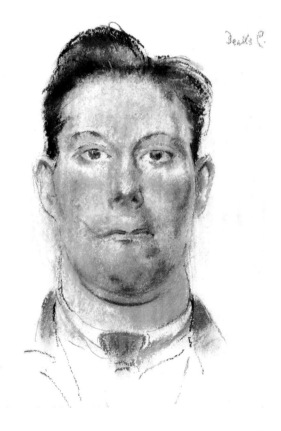

28
William Orpen
Blown Up 1917
Graphite and watercolour
on paper

31
Rosine Cahen
The Amputees'
Workshop 1918
Charcoal on paper

32
Sella Hasse
One-armed War-blinded
Man at the Machine 1919
Linocut on paper

33
Marc Lériche
The Reaper 1917
Plaster, paint and wood

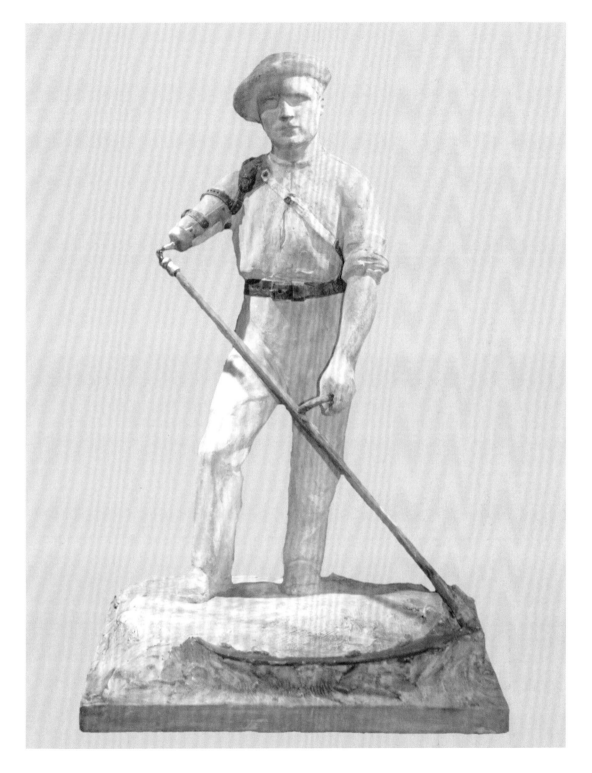

34

34
Heinrich Hoerle
Cripple Portfolio, plate 7:
The Man with the Wooden
Leg Dreams 1920
Lithograph on paper

35
André Mare
Survivors 1929
Oil paint on canvas

36
George Grosz
Blind Man 1923
Graphite on paper

37
George Grosz
*'Are we not fit for the
League of Nations'* 1919
Ink on paper

36

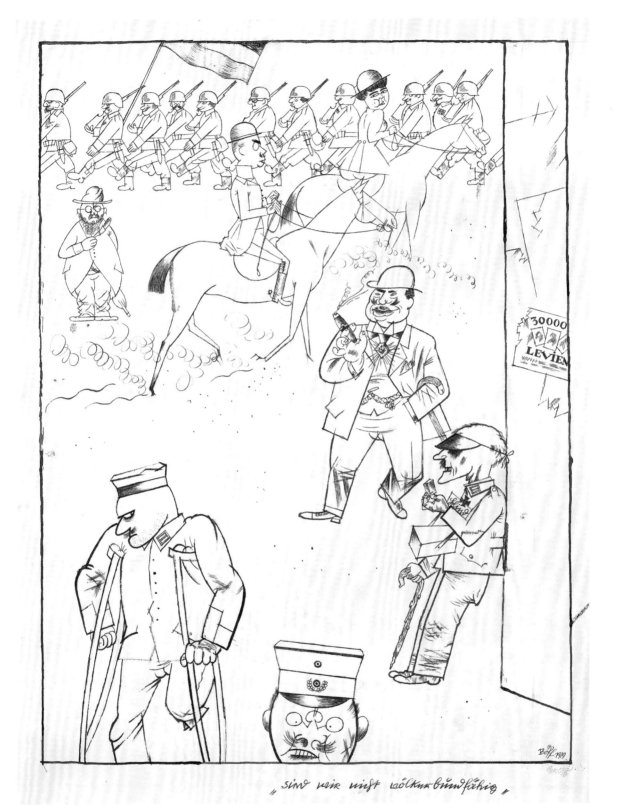

„sind wir nicht völkerbundfähig"

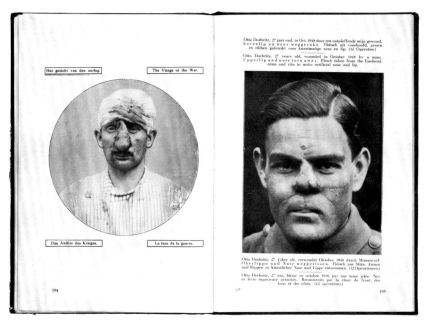

38
Ernst Friedrich
Krieg dem Kriege!
(*War Against War!*) 1924
Book

39
Otto Dix
*Prostitute and Disabled
War Veteran. Two Victims
of Capitalism* 1923
Ink on cardboard

39

40
Opening of the First
International Dada Fair
in Dr Burchard's
bookshop, Berlin

41
Otto Dix
War Cripples 1920
From 'Radierwerk I'
Drypoint on paper

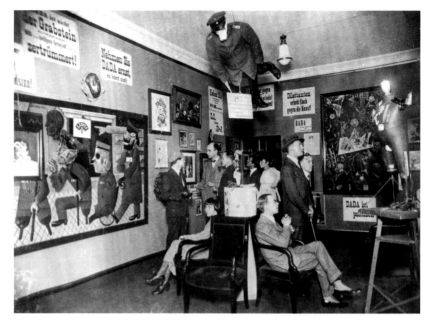

40

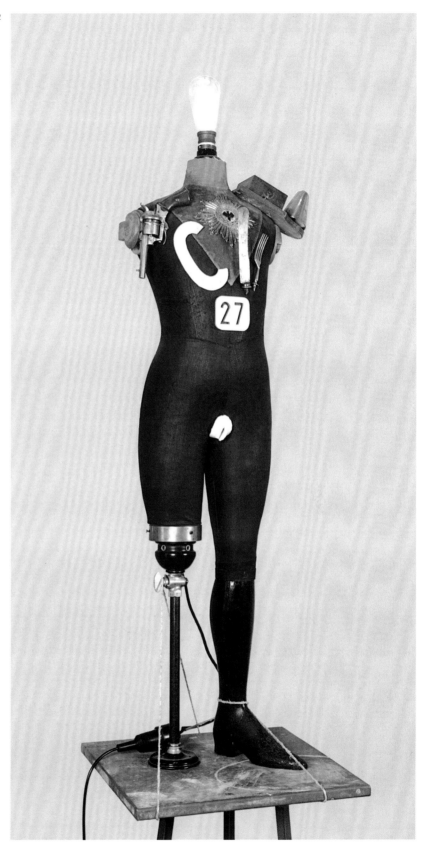

42
George Grosz and
John Heartfield
*The Petit–Bourgeois
Philistine Heartfield Gone Wild
(Electro-Mechanical
Tatlin Sculpture)* 1920,
reconstructed 1988
Mixed media

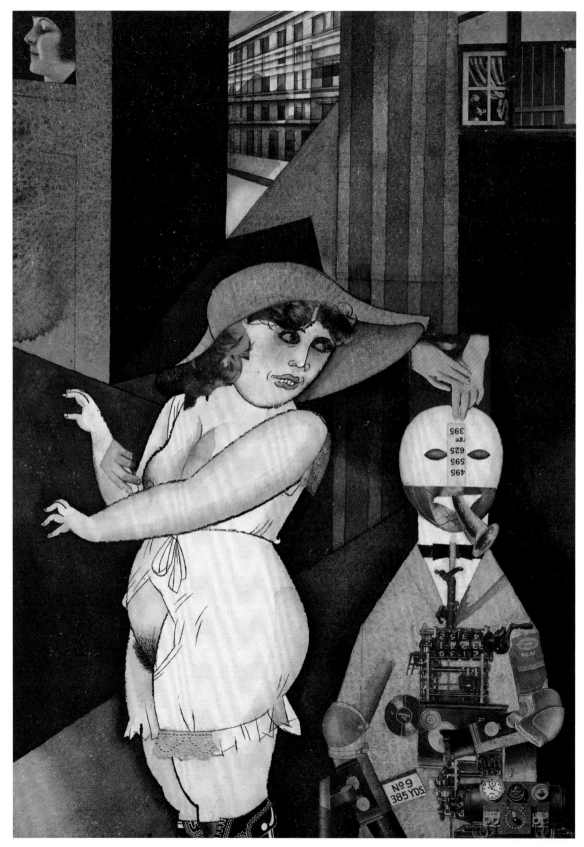

43

43
George Grosz
*'Daum' marries her pedantic
automaton 'George' in May 1920,
John Heartfield is very glad
of it (Meta−mech. constr. after
Prof. R. Hausmann)* 1920
Watercolour, graphite, ink and
collage on cardboard

44
Edward Burra
*The Eruption of
Vesuvius* 1930
Collage and watercolour
on paper

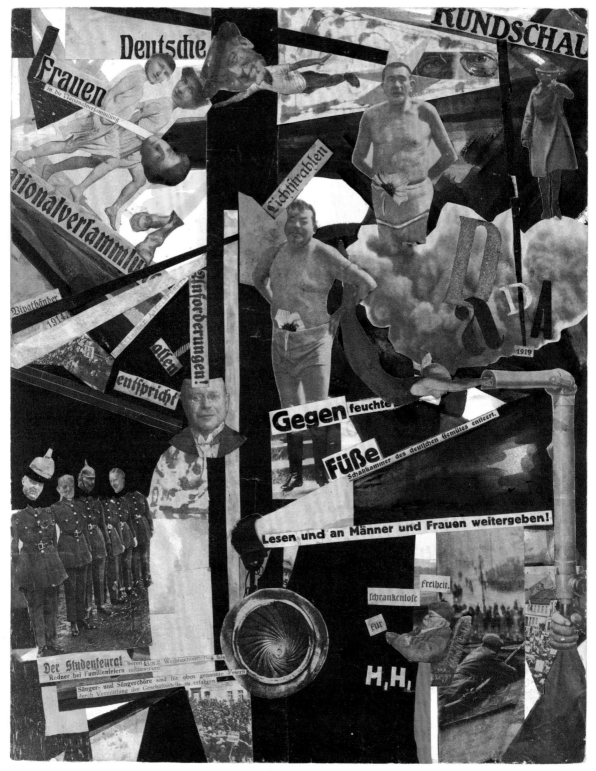

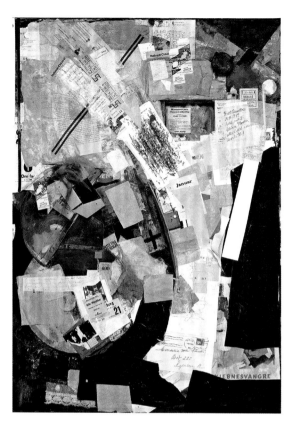

46

46
Kurt Schwitters
*Picture of Spatial
Growths – Picture with
Two Small Dogs*
1920–39
Oil paint, wood, paper,
cardboard and
china on board

47
John Heartfield
Fathers and Sons 1924
Republished
AIZ no. 37 1934
Photomontage

47

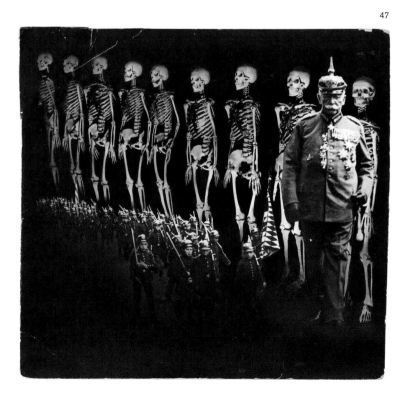

45
Hannah Höch
Dada-Rundschau 1919
Collage, gouache and
watercolour on
cardboard

48
Max Ernst and Hans Arp
Anatomy 1921
Postcard

49
Max Ernst and Hans Arp
*Here Everything is Still
Floating* 1920
Photocollage on card

50
Max Ernst
Celebes 1921
Oil paint on canvas

48

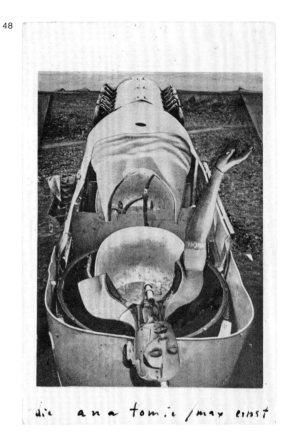

49

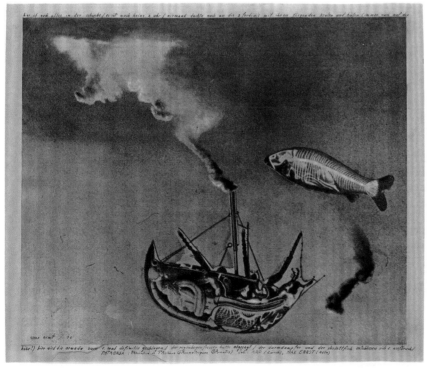

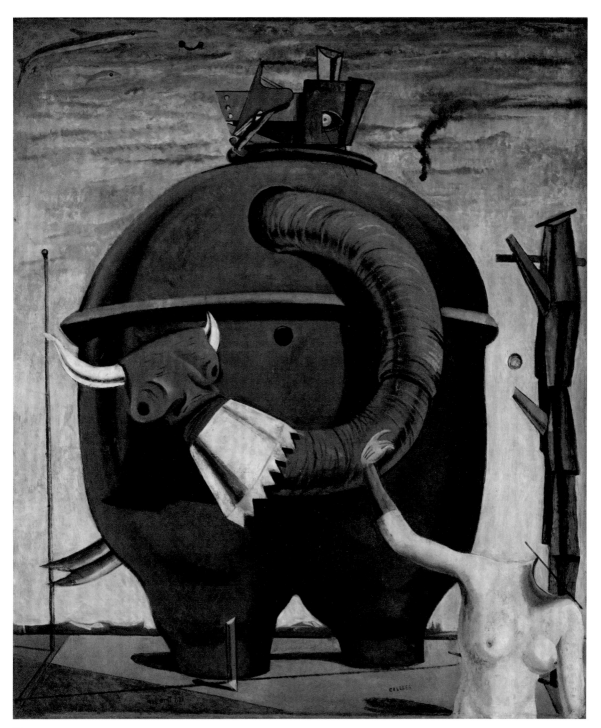

50

51
André Masson
La route de Picardie 1924
Oil paint on canvas

52
André Masson
Lancelot 1927
Oil paint and sand
on canvas

52

53

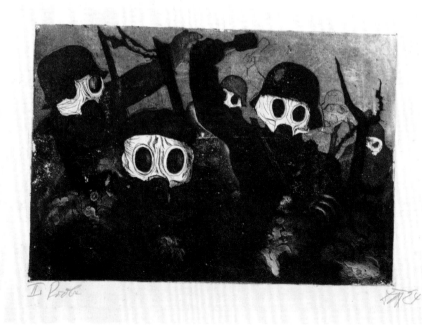

54

53
Max Beckmann
Hell 1919, *plate 2:*
The Way Home
Lithograph on paper

54
Otto Dix,
The War (Der Krieg):
Shock Troops Advance
under Gas 1924
Etching, aquatint
and drypoint on paper

55

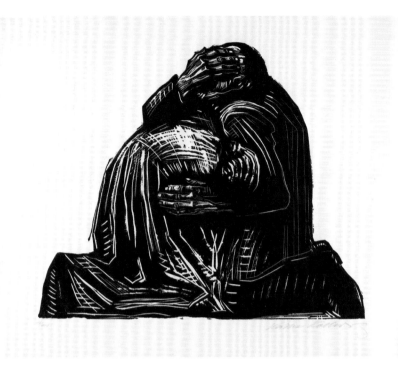

56

55
Käthe Kollwitz
War (Der Krieg) 1921–2,
plate 3: The Parents
Woodcut on paper

56
Georges Rouault
Miserere et Guerre 1926,
published 1948, *plate 54:
'Arise, you dead!'*
Photo-etching, aquatint
and drypoint on paper

The Return to Order

by Simon Martin

In her stream-of-consciousness novel *Mrs Dalloway* (1925), Virginia Woolf wrote of how 'so prying and insidious were the fingers of the European War'.[1] In the years after 1918, the conflict continued to reach far into all aspects of society and the lives of individuals. For the generation of artists that came to prominence in Britain, France and Germany in the 1920s, the First World War was not only a formative experience, nor just a memory, but an inescapable spectre. Its presence was palpable, and its deep impact could be discerned even when the war itself was not immediately apparent as a subject in ostensibly peaceful imagery, such as landscape, portraiture or religious art.

With over ten million dead, twenty million severe casualties and eight million people with permanent disabilities, the immense trauma inflicted on both sides of the conflict was demonstrated in a retreat from avant-garde artistic values and a search for reassurance and stability in tradition.[2] Just as the war memorials that appeared in towns and cities followed a classical style that expressed qualities of restraint, harmony, dignity and respect for the past, so similar values were also articulated in paintings and sculptures of the post-war years. As Ana Carden-Coyne has asserted: 'In the aftermath of the First World War, a classical imagery was rehabilitated, not just as a familiar cultural vocabulary or retreat to the safe past, but as a relevant set of values regarding beauty, symmetry, and civilisation. Since classicism was a universal aesthetic aimed at resolving paradoxes harmoniously, it offered a special understanding of the world in violent conflict.'[3]

'Now that war is over, all is being organised, classified, and purified', declared artist Amédee Ozenfant and architect-painter Le Corbusier in their purist manifesto *Après le Cubism* ('After Cubism') in October 1918, where they also announced their aim to re-establish 'the connection with the époque of the Greeks'.[4] In June 1919, the *Sunday Telegraph* declared that 'Futurism and Vorticism … have all gone under and we are in the full swing of a classical revolution'.[5] In the same year, in his opening paragraph of a review of an exhibition of Braque's paintings, the cubist painter André Lhote announced a '*Rappel a l'ordre*' ('return to order') – a phrase later made famous by the poet and artist Jean Cocteau as the title for a 1926 collection of essays on the subject of classicism in art. There had been a resurgence of interest in the French neo-classical painters Jacques-Louis David and Jean-Auguste Dominique Ingres during the 1910s, and the admiration for their restrained, harmonious style amongst artists was further cultivated in the 1920s by the critics Florent

Fels and Waldemar Georges.[6] The Italian metaphysical painter Giorgio de Chirico's 1919 article 'Il ritorno al mestiere' ('The Return to Craft') was also significant in renewing interest in Renaissance painters.[7]

Artists including Georges Braque, André Derain and Pablo Picasso turned away from cubism to paint images that conveyed a comparative sense of order and calm, abandoning fragmentation for the body complete. Like many artists, Derain had served on the Western Front, observing that 'I don't count the horrors I saw as memories',[8] and he wrote to his fellow former fauvist Maurice de Vlaminck: 'I want to do nothing but portraits, real portraits with hands and hair; that's real life!'[9] During his 1921 trip to Rome, Derain studied the work of Raphael and Jean-Baptiste-Camille Corot who, it was believed, had brought Renaissance values into the nineteenth century and whose influence can be seen in Derain's introspective portrait study of a woman looking out from under a white shawl, *The Italian Model* 1921–2 (no.68).

Picasso had travelled to Italy with Cocteau for two months in 1917 whilst working on his set and costume designs for the ballet *Parade*, and that year he began to paint classical compositions, often featuring solidly rounded women in Grecian robes, such as *Seated Woman in a Chemise* 1923 (no.69) and *Family by the Seashore* 1922 (no.67). Echoing Picasso and Derain's retreat from abstraction into figurative art, there was a parallel 'return to order' amongst the British avant-garde, in particular the Bloomsbury artists Vanessa Bell and Duncan Grant and the vorticists Wyndham Lewis, Edward Wadsworth and William Roberts.

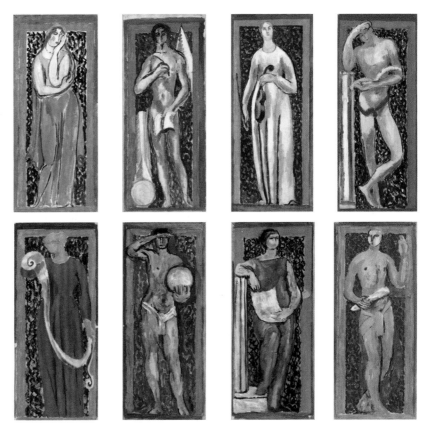

Fig.18
Vanessa Bell and Duncan Grant
The Muses of Arts and Science
1920, Eight studies for murals
for John Maynard Keynes's rooms
at Kings College, Cambridge,
Oil paint on canvas, each
83.8 × 35.5
Private collection

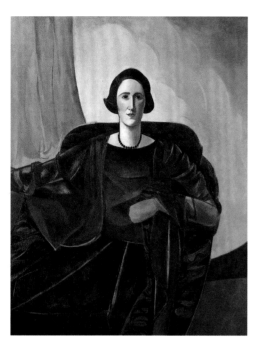

Fig.19
Wyndham Lewis
Mrs Schiff 1923–4,
Oil paint on canvas,
125.7 × 100.3, Tate

In 1921, an exhibition of sixty-two works by Picasso – including works from his Blue, Rose, cubist and neo-classical periods – was held at the Leicester Galleries in London, accompanied by a catalogue with a text by the Bloomsbury critic Clive Bell. Inspired in part by trips to Italy and friendship with Picasso and Derain, Vanessa Bell and Grant were to abandon the pre-war abstraction of the Omega Workshops for the substantial female figures of paintings such as Grant's *Venus and Adonis* 1919 and the murals of *The Muses of Arts and Sciences* for John Maynard Keynes' Rooms at King's College, Cambridge produced by both artists in 1920 (fig.18). Lewis was suspicious of the classical revival in French art; nonetheless, his portraits of the 1920s were to abandon vorticist machine forms for a restrained visual language that owed a debt not only to Picasso but also the elegant draughtsmanship of Ingres, as in his portrait *Mrs Schiff* 1923–4 (fig.19).

The sculptural qualities of Picasso's paintings of neo-classical figures influenced the early works of Henry Moore, as expressed in the monumentality of form and curves of his Portland stone figure *Standing Woman* 1924. Before the war, Eric Gill's Anglo-German patron Harry, Count Kessler had attempted to bring him to France as apprentice-assistant to the French neoclassical sculptor Aristide Maillol; although this plan did not come to fruition, Gill admired and maintained a friendship with the French sculptor whose voluptuous figures, such as the bronze *Venus with a Necklace* c.1918, cast 1930, expressed a serene, immutable classicism.[10] Gill's *Mankind* 1927–8 emulates the idealised beauty and perfection of a statue from antiquity that has survived in fragmentary form.

The knowing referencing of antique sculpture was a device employed by numerous artists, in particular Dod Procter in her celebrated painting *Morning* 1926 (no.74). Ostensibly an image of a young girl awakening, the pose and draped form is a modern reinterpretation of the *Sleeping Ariadne*, one of the most renowned sculptures of antiquity. When it was first exhibited at the Royal Academy Summer Exhibition in 1927 reviewers compared Procter's painting to the classical works of Picasso and Derain, and to antique and Renaissance sculpture, praising its 'monumental plasticity of form'[11] and declaring it to represent 'the new vision of the twentieth century'.[12]

A similar statuesque modern classicism was expressed by Meredith Frampton in his portrait *Woman Reclining (Marguerite Kelsey)* 1928 (no.73), which encapsulates the qualities of restrained simplicity, formal clarity, elegance, and idealised beauty. The white dress and presentation of the sitter recall David's celebrated neoclassical *Portrait of Madame Récamier* 1800 in the Louvre, Paris. Frampton's paintings were representative of a form of hyper-real classical painting in Britain during the interwar years, embodying characteristics such as control, close scrutiny, a respect for tradition, sharpened clarity, restraint and purity of line. Although a traditionalist, who was perhaps most at home exhibiting in the Royal Academy, Frampton's hard edge realism seems to relate closely

to that of the European artists in whose company his paintings would have appeared when he was represented at the Carnegie International Exhibitions in Pittsburgh during the 1930s, including the artists associated with the *Valori Plastici* in Italy, such as Cagnaccio di San Pietro, and the German *Neue Sachlichkeit* (or 'New Objectivity') artists.

The precision of the *Neue Sachlichkeit* artists represented a reaction against Expressionism and a search for clarity amidst the political turmoil of Weimar Germany. The group's name was coined in 1923 by Gustav Friedrich Hartlaub (1884–1963), Director of the Mannheim Kunsthalle, who used it as the title of an exhibition in 1925. Hartlaub noted that 'what we are displaying here is distinguished by the – in itself purely external – characteristics of the objectivity with which the artists express themselves.'[13] He divided the artists into 'classicists', such as George Scholz (fig. 20) and Georg Schrimpf, who exemplified the wider European 'return to order' with pastoral images, such as *Midday Rest* 1922 (no.66), and the left-wing 'verists' Otto Dix, George Grosz, Christian Schad and Rudolf Schlichter, who emphasised a harsher form of reality that eschewed idealism for a clinical precision, as in Schlichter's

Fig.20
Georg Scholz
Female Nude with Plaster Bust 1927, Oil paint on canvas, 65.5 × 55, Staatliche Kunsthalle, Karlsruhe, Germany

Jenny 1923 (no.72) or Schad's *Self-Portrait* 1927 (no.75), in which the nude female beside the artist has a lengthy *freggio* scar on her face. Having lived in Italy from 1920–5, Schad's work was especially influenced by Raphael – but, arguably, these artists looked more intently at their native Germanic tradition of old masters including Albrecht Dürer and Hans Holbein.

From 1924 onwards, the Berlin-based Albert Birkle created modern religious paintings with a strong social-critical aspect, such as *Cross shouldering (Friedrichstrasse)* 1924 (no.64), in which a Christ-like figure is depicted in the crowded streets of contemporary Berlin, disregarded by those around him, including two policemen on horseback – a scene that pays homage to Northern Renaissance treatments of Christ carrying the cross (fig.21). The same scene from Christ's Passion was also reimagined in a British setting by the devoutly Christian artist Stanley Spencer in *Christ Carrying the Cross* 1920 (no.65), relocating the episode to the High Street of Cookham. In this and other works Spencer, informed by his love of the Italian Primitives, sought to depict his home town as a 'holy suburb of Heaven', as in *The Resurrection, Cookham* 1924–7 and *Unveiling Cookham War Memorial* 1922 (no.24), which takes its formal structure from Giotto's *The Last Judgement* c.1305 in the Scrovegni Chapel, Padua.[14] Spencer's experiences of serving at the Beaufort War Hospital near Bristol and on the Macedonian Front informed his own highly idiosyncratic war memorial, a cycle of murals created between 1927 and 1932 for the Sandham Memorial Chapel in Burghclere (fig.22). This scheme is not about death or violence, but the experience of living in wartime, the promise of life beyond death through memorialisation, and the existence of the past in the present.

Like Spencer, David Jones and Winifred Knights combined elements from early Italian art and modernist painting in their work. *The Deluge* 1920 (no.63), Knights' prizewinning entry for the British School at Rome's Scholarship in Decorative Painting, was described by *The Studio* in 1921 as 'an attempt to apply Cubism to realistic painting'.[15] Inspired by the Old Testament story of Noah, it can be seen as a lament for the First World War, created after Knights had seen the exhibition *The Nation's War Paintings and Other Records,* which opened in London on 12 December 1919 and featured 925 contemporary paintings and sculptures commissioned from British artists under the official war artists' schemes. Jones had served on the Western Front, and this experience was to form the basis of his epic poem *In Parenthesis* (published 1937). A devout convert to Catholicism, he joined Eric Gill's Guild of St Joseph and St Dominic, based on a medieval

Fig.22
Stanley Spencer
The Resurrection of the Soldiers, Oil paint on canvas, 640.5 × 53.6, Sandham Memorial Chapel, Hampshire

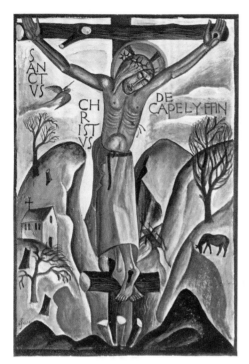

Fig.23
David Jones
Sanctus Christus de Capel-y-ffin, 1925,
Gouache and pencil
on paper,
19.3 × 13.3, Tate

guild model, in Ditchling, Sussex, where he painted *The Garden Enclosed* 1924 to mark his engagement to Gill's daughter Petra. Between 1924 and 1927 he regularly visited Gill and his family, whose move to Capel-y-ffin in South Wales to pursue a rural way of life inspired images such as Jones' crucifixion set in the Black Mountains, *Sanctus Christus de Capel-y-ffin* 1925 (fig.23).

A retreat into the solace of the rural landscape, both metaphorical and actual, was manifested in the work of numerous artists in the 1920s. In France, honest peasant labour – a subject that Remy Golan has linked to the high proportion of French peasants who were mobilised and killed in the war[16] – was depicted in such paintings as *The Reaper* 1924 by the social realist artist Marcel Gromaire and *The Herdsman* 1921 by the former cubist Roger de la Fresnaye (no.59), whilst in Germany Georg Schrimpf painted comparable subjects, such as *Swineherd* 1923 (no.60). In Britain, a revival of interest in a national landscape tradition, in particular the artists John Sell Cotman and Samuel Palmer, inspired engagement with the landscape.

At the end of the First World War John Nash had painted *The Cornfield* (no.57), a depiction of the low evening sunlight on freshly-harvested fields, featuring a row of neatly-grouped corn stooks. It is a reassuring image of continuity and stability, of timeless activities seemingly untouched by war. Produced in late summer 1918 after the artist had been demobilised, it was the first painting Nash made that did not depict the conflict, and he wrote of how he and his brother, Paul Nash, only painted for their own pleasure after six o'clock, when their work as official war artists was completed for the day. The contrast with their paintings of the devastation and blasted trees in the trenches on the Western Front could not be greater, and yet the shadow cast over the landscape is long and inevitably seems symbolic. In 1921, Paul was diagnosed as suffering from 'emotional shock' as a result of his wartime experiences. At the end of the decade, Paul painted the view from his Sussex studio, *Landscape at Iden* 1929 (no.61), featuring an altar-like pile of logs that has been read as a symbolic statement of mourning for fallen humanity.[17] Yet the painting also suggests an enduring, hopeful and mystical quality in the landscape.

Paul Nash was conscious of the tension between modernity and tradition that faced his generation, and the question of how British artists related to their contemporaries on the continent, when he wrote the article 'Going Modern and Being British' in 1932.[18] In the same year the curator Hildebrand Gurlitt organised an exhibition of 'New English Art' at the Hamburg Kunstverein, which suggested an affinity between certain British artists and the *Neue Sachlichkeit* tendency in German art and included works by Edward Burra, Ben Nicholson, Roberts, Spencer, Wadsworth, Christopher Wood, and the sculptors Barbara Hepworth, Moore, John Skeaping and Leon Underwood.[19] Of these, it is Burra who had most in common with his German contemporaries, both stylistically and in terms of subject matter. His depiction of a prostitute in *Snack Bar*

1930 (no.94) reflects his enthusiasm for Grosz's satirical depictions of brothels, such as the series *Ecce Homo* 1922–3.[20] Glyn Philpot, who travelled to Berlin in autumn 1931, was probably one of the few artists to experience firsthand the *Neue Sachlichkeit* artists' work in Germany, an experience that informed paintings such as *Local, Berlin* 1931–2 and the Parisian scene *Entrance to the Tagada* 1931–2 (no.87).

Direct cultural connections between artists in Britain and Germany were limited during the 1920s, partly due to postwar suspicions of Germany and the dominant Francophile influence of the Bloomsbury Group, a situation that only shifted with the arrival in Britain of German artists fleeing the Nazis after 1933. In spite of this, there were powerful and striking resonances between the art made in Britain, France and Germany in the period. Perhaps this was because, in creating a modern art that reflected their times, these artists also looked back far before the conflict that had divided them, seeking to reinvigorate their art through reference to the past. In his 1921 essay 'Tradition and the Individual Talent', T.S. Eliot wrote of his belief that 'Tradition is a matter of much wider significance. It cannot be inherited, and if you want it you must obtain it by great labour. It involves, in the first place, the historical sense, which we may call nearly indispensable.'[21] For the artists seeking to understand the enormous shifts in society in the aftermath of the First World War there was a powerful resonance with Eliot's view that 'the past should be altered by the present as much as the present is directed by the past.'[21] **SM**

1 See Karen L. Levenback, *Virginia Woolf and the Great War*, New York 1999, p.61.
2 This figure is cited in Ana Carden-Coyne, *Reconstructing the Body: Classicism, Modernism and the First World War*, Oxford 2009, p.1.
3 Carden-Coyne 2009, p.2.
4 Amédée Ozenfant & C.E. Jeanneret, *Après le Cubism*, Paris, 5 Oct. 1918.
5 *Sunday Telegraph*, 29 June 1919.
6 A retrospective of David's work at the Petit Palais in Paris in 1913 had led to a revival of interest in the artist's work.
7 De Chirico, 'Il ritorno al mestiere', *Valori Plastici I*, Nov. – Dec. 1919. See 'Classicismo Pittorico' in Giorgio de Chirico, *Scritti*, ed. Andrea Cortilessa, Milan 2008, p.308.
8 Jane Lee, *Derain*, Oxford 1990, p.54.
9 André Derain to Maurice de Vlaminck. Quoted in Lee 1990, p.56.
10 See Fiona MacCarthy, *Eric Gill*, London 1990, p.101.
11 *Manchester Guardian*, 30 April 1927.
12 Frank Rutter, *Sunday Times,* 1 May 1927. Quoted in Elizabeth Knowles, *Dod Procter RA 1892–1972, Ernest Procter ARA 1886–1935*, Newcastle-upon-Tyne 1990, p.14.
13 G.F. Hartlaub, 'Introduction to New Objectivity: German Painting since Expressionism', exh. cat., Mannheim Städtische Kunsthalle, 1925. Quoted in Anton Kaes, Martin Jay and Edward Dimendberg, *The Weimar Republic Sourcebook*, Oakland, CA 1995, p.492.

14 See Simon Martin, '"What Ho, Giotto!": Stanley Spencer's Holy Box and the Influence of the Italian Primitives' in Amanda Bradley (ed.), *Stanley Spencer: Heaven in a Hell of War*, Chichester 2014, pp.53–62.
15 *The Studio*, vol.82, no.344, Nov. 1921, p.190.
16 See Remy Golan, *Modernity and Nostalgia: Art and Politics in France Between the Wars*, New Haven and London 1995, pp.40–5.
17 See Mary Beal, '"For the Fallen": Paul Nash's Landscape at Iden', *Burlington Magazine*, vol.141, no.1150, Jan. 1999.
18 Paul Nash, 'Going Modern and Being British', *Weekend Review*, 12 March 1932.
19 See Meike Hoffmann and Nicola Kuhn, *Hitlers Kunsthändler: Hildebrand Gurlitt 1895–1956: Die Biographie*, Munich 2016.
20 Burra's friend Barbara Ker Seymer recalled their shared interest in Grosz's work in a letter of 4 July 1982, quoted in M. Kay Flavell, *George Grosz: A Bibliography*, New Haven and London 1988, p.53.
21 T.S. Eliot, 'Tradition and the Individual Talent' (1919), in T.S. Eliot, *The Sacred Wood*, New York 1921.
22 Ibid.

The Return to Order

58

57
John Nash
The Cornfield 1918
Oil paint on canvas

58
Félix Vallotton
Road at St Paul (Var) 1922
Oil paint on canvas

59
Roger de la Fresnaye
The Herdsman 1921
Oil paint on wood

60
Georg Schrimpf
Swineherd 1923
Oil paint on canvas

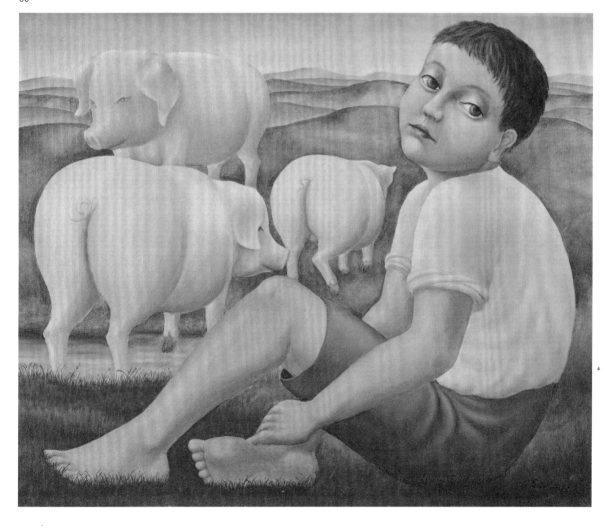

61
Paul Nash
Landscape at Iden 1929
Oil paint on canvas

62
Franz Lenk
Old Military 1930
Oil paint on canvas on wood

61

62

63
Winifred Knights
The Deluge 1920
Oil paint on canvas

64
Albert Birkle
*Cross Shouldering
(Friedrichstrasse)* 1924
Oil paint on canvas

65
Stanley Spencer
*Christ Carrying
the Cross* 1920
Oil paint on canvas

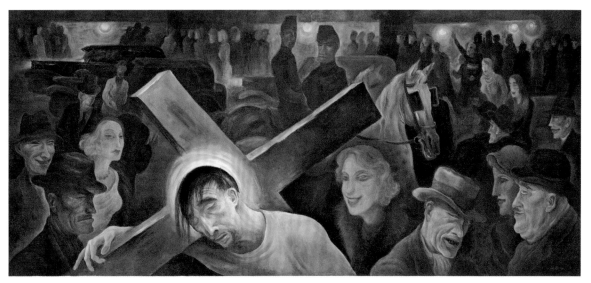

64

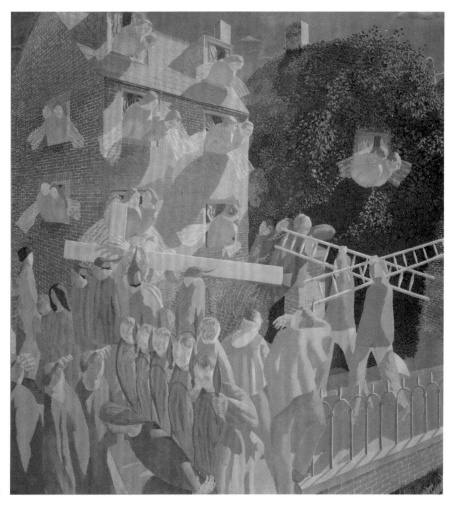

65

67

66
Georg Schrimpf
Midday Rest 1922
Oil paint on canvas

67
Pablo Picasso
Family by the Seashore 1922
Oil paint on wood

68

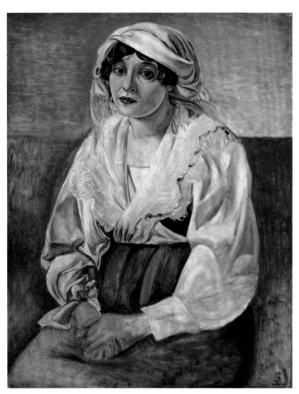

69

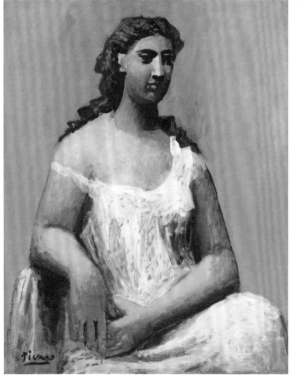

68
André Derain
L'Italienne 1920–24
Oil paint on canvas
on plywood

69
Pablo Picasso
*Seated Woman in
a Chemise* 1923
Oil paint on canvas

70
Georges Braque
Bather 1925
Oil paint on board

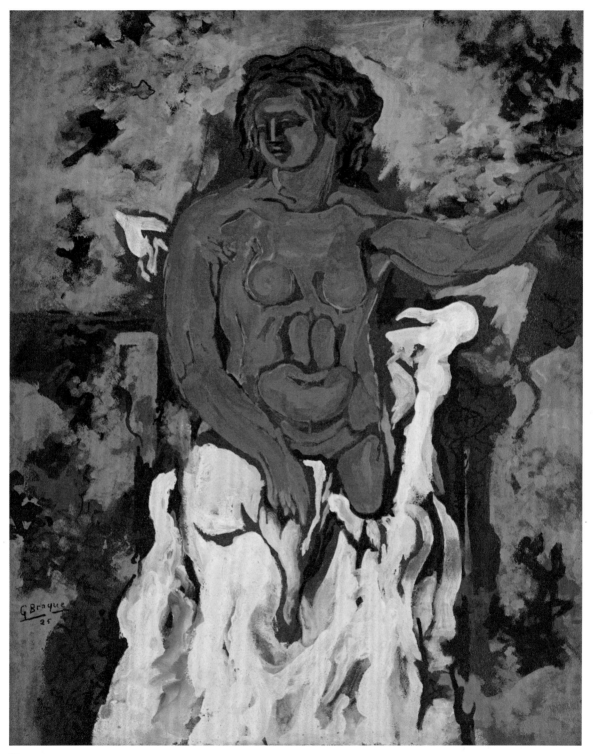

70

71
Dorothy Brett
War Widows 1916
Oil paint on canvas

72
Rudolf Schlichter
Jenny 1923
Oil paint on canvas

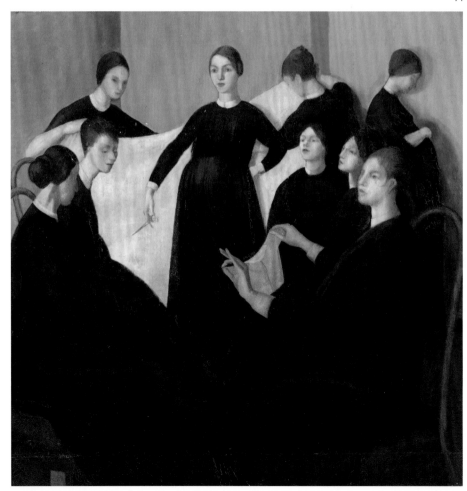

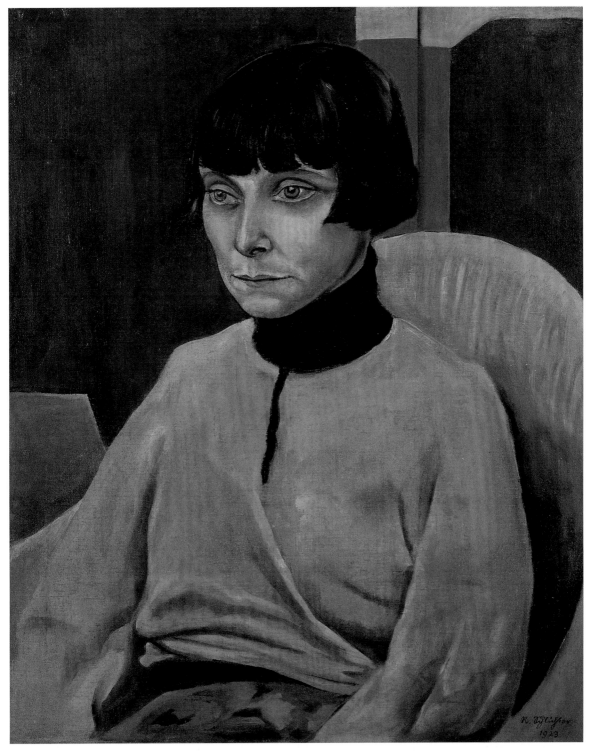

72

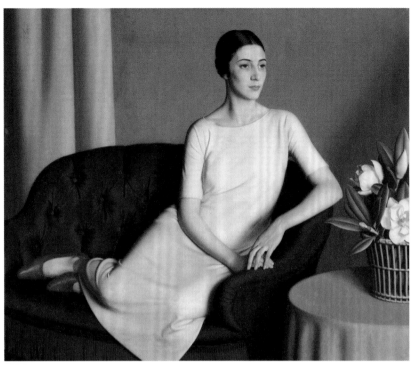

73

73
Meredith Frampton
Marguerite Kelsey 1928
Oil paint on canvas

74
Dod Procter
Morning 1926
Oil paint on canvas

75
Christian Schad
Self-Portrait 1927
Oil paint on wood

74

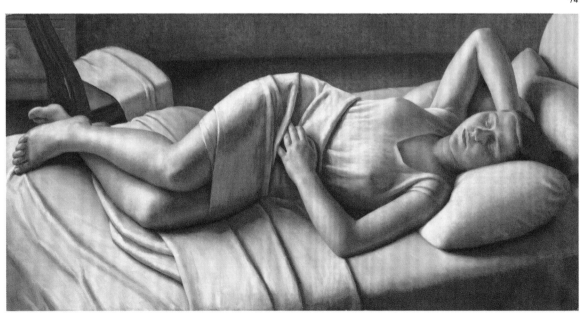

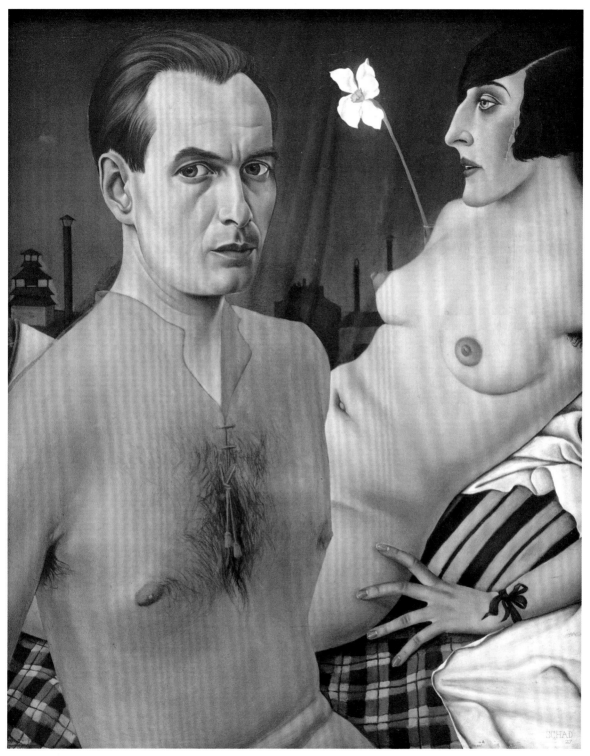

75

Remaking Society

by Dorothy Price

'I wish those people who write so glibly about this being a holy war …
could see a case of mustard gas – the poor things burnt and blistered all
over with great mustard coloured suppurating blisters, with blind eyes,
all sticky and stuck together, and always fighting for breath, with voices
a mere whisper, saying their throats are closing and they know they
will choke …'

Vera Brittain, *Testament of Youth* (1933)

Vera Brittain's poignant memoir, her witness to war and to the lives of
a generation of young men lost to it, confronts us unequivocally with
the physical horrors of trench warfare wrought on the bodies of young
men during the First World War. Indeed, visual images of damaged
and mutilated bodies proliferated in the aftermath of war, as many
artists struggled to come to terms with the violence and brutality
that they and their comrades had endured on the battlefields. Yet
whilst the physical experiences of war are viscerally palpable in much
postwar art, particularly in iconic works by artists like Otto Dix, there
is also poignant emotional symbolism in the work of many others.
C.R.W. Nevinson's *Paths of Glory* 1917 (no.7) and Paul Nash's *Wire*
1918–19 (no.4) both index the lacerating effects of the trenches on
the bodies of men, Nevinson physically, Nash symbolically.
 Two works by Wilhelm Lehmbruck seem to bookend the unprece-
dented catastrophe of this war: made in the milieu of the international
avant-garde in Paris only a year before the outbreak of war, his
optimistic *Ascending Youth* 1913 (fig.24) strives upwards, full of hope;
his desolate and defeated *The Fallen Man* (no.1) was executed in
Berlin in 1915, by which time Lehmbruck was employed as an orderly
in a military hospital, having been expelled from Paris as an 'enemy
alien'. Their posthumous tragedy is further heightened when we learn
of Lehmbruck's suicide in 1919. These two sculptures, it seems to
me, succinctly tell the story of naïve optimism and bitter defeat that
marked the destruction and disappearance of the heroically idealised
male body on an unprecedented scale in just four years, between 1914
and 1918. Remaking society in the aftermath of such a devastating war,
in which over ten million young men died on the battlefield of Europe
(and which was followed by the brutal Spanish flu pandemic, in which
another forty million or so people worldwide were wiped out – about
a quarter of a million in Britain), was not an easy prospect. For those
of Europe's soldiers who managed to limp home (often in various states

of able-bodiedness) from the horrors of the trench, peacetime conditions remained grim. Across Britain, France and Germany, the returnees were met by economic hardship, mass unemployment, high prices, poor housing and widespread poverty. In Germany, the Kaiser had abdicated and civil war erupted on the street. Political instability and a decimated economy set the tone for the decade to come.

Lehmbruck's elegiac sculpture to the tragedy of male youth in *The Fallen Man* offers a restrained, melancholic and contemplative means for imagining the trauma of the individual soldier wrecked by the maelstrom of war. Yet, like all of Lehmbruck's figure studies, the body remains intact; it becomes a vehicle for the outward expression of inner emotion. The monumental bronze form, bowed in utter despair, allows the viewer space for emotional empathy without aesthetic revulsion. But one thing about the First World War was certain: the body of the frontline soldier rarely remained intact. Male bodies were repeatedly maimed and there were more amputations conducted during this war than any before or since.[1] Despite this, veterans with facial injuries were often excluded from the public discourse around disability and recovery; photographs of soldiers with facial injuries (of whom there were significantly more than those who had limb amputations) were generally kept out of the popular press reports about advances in surgical treatments and prosthetic reconstruction.[2] Henry Tonks however, a fine art tutor at the Slade School in London (subsequently appointed Slade Professor in 1918) as well as a trained surgeon, is exceptional in the British context for his portraits of soldiers with facial injuries sustained during the conflict, who he drew from life as part of his work for Harold Gillies' plastic surgery unit at the Cambridge Hospital in Aldershot from 1916. (nos.29, 30)

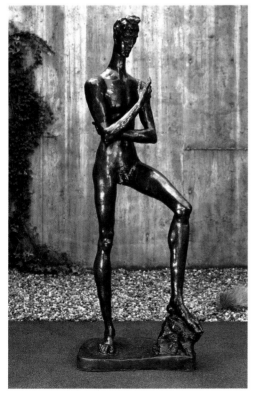

Fig.24
Wilhelm Lehmbruck
Ascending Youth 1913,
cast 1924, Bronze,
226 × 76 × 56,
Lehmbruck Museum,
Duisburg

In his role as draughtsman, Tonks' job was to record the facial surgeries of patients, before and after an operation, as a supplement to accompanying black and white photographs that medically recorded and archived their treatment. Yet beyond these functional, diagrammatic drawings, Tonks also produced a series of pastel portraits of the patients he encountered, also depictions of before and after surgery. It is these delicate renditions in colour, 'fragments' as he called them, that move beyond surgical documentation to raise questions of aesthetic vulnerability and loss.[3] Tonks returns to these men the possibilities of an interior life that the medical gaze of documentary photography and accompanying surgical diagrams had excised. The lives and identities of the young men whom Tonks recorded would never be the same again, no matter how much surgery or prostheses they endured; the pastel portraits offer a moving testimony to the visceral horrors of war on the faces of the men who survived it.

Much more aggressive and uncompromising renditions of the maimed, scarred and lacerated faces of soldiers are Otto Dix's brutal monochromatic etchings of disfigured and mutilated men rotting in the mud where they fell (fig.25). In 1914 Dix had volunteered for military

service; unlike most of the artists of his generation, he ended up fighting and, remarkably, surviving the full four years of battle, mainly as a machine gunner in the trenches of the Western and Eastern Fronts. He was injured five times and awarded the Iron Cross for bravery in 1915. Between 1914 and 1918 he also continued to sketch, producing a remarkable body of works on paper, small in size, some rendered in gouache but most in black chalk – portraits of soldiers entangled in conflict, self-portraits in various guises, and sketches of the cratered, war-torn landscapes in which they fought daily for survival:

The war is something animalistic: hunger, lice, mud, those insane odours. Everything is completely different. You know, standing in front of earlier paintings, I had the feeling that one side of reality was not being depicted at all: the ugly. War was a terrible thing but nevertheless something powerful, I definitely could not neglect that! You have to have seen people in this untamed state to know anything about them.[4]

In the immediate postwar years, dada Dix revelled in the iconoclastic anarchism that the German avant-garde afforded him. His bitingly satirical renditions of man-machines, former soldiers so eviscerated by war that they could barely function on civvy street, depicted bodies grotesquely malformed by inadequate prostheses, all traces of potential empathy strangled by the sheer outlandishness of their situation. Three drypoint etchings from 1920 – *Match-Seller, Card Players* and *War Cripples* – are unmatched in the scathingly bitter attitude displayed by their creator. These are early examples of Dix's newfound technique of which he famously observed that 'when you etch you're a complete alchemist.'[5] Many scholars have observed how the corrosive processes involved in the etching technique, in which large holes can be bored into the plate by acid, mimics the expressive potential of Dix's subject matter.[6] But it was not until 1924, on the tenth anniversary of the outbreak of war, that he deployed the destructive elements of the process to full effect

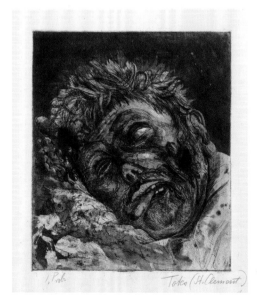

Fig.25
Otto Dix
'Dead Man (St. Clément)'
from *The War (Der Krieg)*
1924, Etching, aquatint
and drypoint on printing
paper, 47 35, Museum of
Modern Art, New York

in *The War (Der Krieg)*. This remarkable fifty-print etching cycle, divided into five portfolios containing ten prints each, became one of the most powerful graphic testimonies of the day against the Weimar Republic's tendency to valorise a heroic war. This tendency was at its most virulent in Ernst Jünger's popular right-wing novel *Storm of Steel* (first published in 1920 and revised for re-publication in 1924), a memoir of Jünger's wartime experiences as a soldier on the western front. Weimar audiences, demoralised by narratives of their nation's defeat, could instead revel in Jünger's glorification of war and feel vindicated by the notions of noble sacrifice propounded therein. In visual terms, heroic imagery centred on the body of the ideal male warrior became a primary index of German patriotism during the Weimar era; veterans who articulated the negative experiences of the war were increasingly 'branded as unpatriotic and cowardly.'[7] Such hostility towards them was exacerbated

by the widespread nationalist conservative myth that the German army had not been defeated in the field but had been betrayed, 'stabbed in the back', by socialist revolutionaries at home.[8]

It was against this background that Dix first produced his monumental painting *The Trench* 1920–3 (now lost), swiftly followed by *The War*. With these works and others, Dix was making a powerful protest against peacetime narratives that consistently undermined and undervalued the veterans' lived experiences of the horrors of war. As postwar Germans were embracing the jazz age, their wounded, maimed and disabled veterans were being discarded as an embarrassing legacy of a failed conflict that no-one cared to be reminded of.

Depicting the inner life of the tormented war veteran became the concern of a completely different approach to the aftermath of war by Cologne-based artist Heinrich Hoerle. Hoerle had served at the Front for only a brief period from 1917 until the end of the war in 1918 but as with all survivors from this otherwise unimaginably barbarous period, the suffering induced by the war on the soldiers he witnessed in combat, left an indelible mark on his visual imagination and psychic stability. As Hal Foster observes of Max Ernst's immediate postwar dada work, fragmented bodies serve as signs for 'a bashed ego' hovering between 'evocations of the narcissistic damage incurred during the war' and 'caution against the reactionary obsession with the body armour' of fascism that followed.[9] A similar pattern can be discerned in Hoerle's oeuvre from the same period. His *Krüppelmappe* or *Cripple Portfolio* 1919 (fig.26) consists of twelve delicately executed lithographs asking viewers to 'Help the Cripple' and drawing attention to the plight of the individual war-wounded soldiers seeking to reintegrate themselves into a society and an economy unable and unwilling to properly support them after their bitter defeat. In the twelve plates, maimed and wounded veterans are shown in different roles: seeking comfort from loved ones; begging on the streets; haunted by missing limbs, mired in nightmares of exaggerated sexual fantasies; engulfed in both physical and psychological loss, and received with fear and horror by those around them. As the portfolio unfolds, a clear progression emerges from the first prints to the last. The first six plates consist of a politically engaged socialist critique of the daily inequities faced by former soldiers now crippled and reliant on ineffectual prostheses, whilst the second six plates chart their descent into a psychological and sexual hell. The 'crippled' war veterans of Hoerle's portfolio are ultimately left abandoned by society and haunted by their own psychological traumas and sexual fantasies.

Hoerle's exploration of the traumatic postwar experiences of the horrors of the battlefield in the *Cripple Portfolio* remained a significant theme in his increasingly socially informed artwork in interwar Germany. By 1930, the psychic realities of mental anguish made explicit in the *Cripple Portfolio* were supplanted in Hoerle's oeuvre by the material realities of the fragmented soldier's body, dependent on prosthetic limbs

Fig.26
Heinrich Hoerle
'Help the Cripples' from
Der Krüppelmappe
(*Cripple Portfolio*) 1920,
Lithograph on paper,
55.8 × 46,
National Gallery of Art,
Washington

and memorialised that year in two striking paintings, *Monument to the Unknown Prostheses* (fig.27) and *Three Invalids (Machine Men)*. The stylistic shift between the 1920 portfolio and the 1930s paintings is palpable. In the intervening decade, the prosthetic body had become a visual paradigm for the era's fascination with human and machine, perhaps represented at its most futuristic in Fritz Lang's epic science fiction film *Metropolis* (1926). Hoerle remained unique in his depiction of the prosthetic body as both a site of empathy and a symptom of the worker's alienation within the mechanised environment of industrial technological labour. If the *Cripple Portfolio* was a passionate moral protest against the inhumanity of war, *Monument to the Unknown Prostheses* and *Three Invalids* were bitter acknowledgements of the sensory losses engendered by the postwar reconstruction of Weimar Germany. Their machine-aesthetic had become a dominant visual trope of the aftermath era – but as artists like Alice Lex-Nerlinger demonstrate, it was an aesthetic that was no longer confined to the depiction of the soldier's broken body.

Lex-Nerlinger belonged to an emerging generation of postwar women, newly enfranchised and taking all the opportunities they could to carve creative careers for themselves. In the late 1920s she turned to photomontage in her search for an adequate pictorial language to critique the social conditions in which she and many women of her generation found themselves:

We were all hot-headed young artists struggling to find new ways in painting. We had been acquainted with war and chaos. We had seen enough of the hollow, empty and mechanized effects of capitalism on culture. And what was a person's value in this system? – only as much as capitalism earned from his labour…[10]

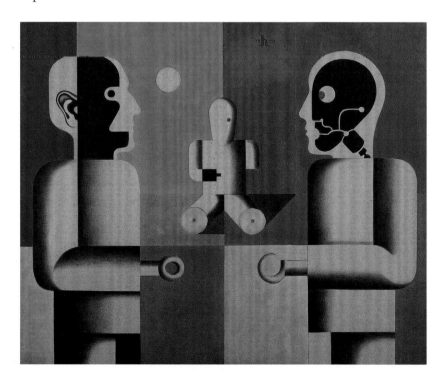

Fig.27
Heinrich Hoerle
Monument to the Unknown Prostheses 1930
Oil on cardboard, 66.5 x 82.5,
Von der Heydt-Museum,
Wuppertal

Influenced by Berlin dadaist John Heartfield to use her art for political critique on behalf of the underprivileged, Lex-Nerlinger's preferred working tools were the photogram, stencil, scissors and spray gun. Collages such as *Untitled* (fig.28) and *Work! Work! Work!* (fig.29), both begun in 1928, were examples of Lex-Nerlinger's explicit drive to 'show how for the employer, the worker meant nothing more than a part of his machine, and in fact one that was easy to replace.'[11] Within the discourses of postwar capitalism, the maimed body of the First World War soldier, for whom the new society no longer had a purpose, was dispensed with in favour of the alienated body of the machine-age labourer. But alienated male bodies of proletarian factory workers weren't Lex-Nerlinger's only concern and she is perhaps best known for her 1931 spray painting *Paragraph 218*. This iconic work was a polemical call to overturn paragraph 218 of the German constitution, which restricted women's rights to abortion and birth control and was widely regarded by the political left as detrimental to proletarian women in particular but also to the wider project of women's emancipation during the Weimar era.

Whilst across Europe the aftermath of war was a chaotic, depressing and debilitating time for its veterans, it was also a time of radical political, economic and social change for women. In 1918 in Britain, women who were householders and over the age of thirty gained the right to vote, whilst in Germany it was awarded to women aged twenty and above. Women in inter-war Europe were experiencing changes in all aspects of their lives, from the desolate experiences of premature widowhood and bereaved motherhood, to the promise of a modern industrialised future in which technological advances would offer new efficiencies in the home and the workplace. The perceived increase of women in the public realm went hand in hand with new forms of urban leisure and entertainment specifically targeted at female audiences. The media myth of the 'new woman', a trope popular in Europe and America since the late nineteenth century, was reborn for the era of mass entertainment, advertising and urban spectacle. Images of the new woman in multiple guises – from 'flapper' to 'garçonne', androgynous 'boy' to beautiful 'girl' – became a predominant subject matter for artists and illustrators alike. She circulated widely in the pages of the popular press and was

Fig.28 (above)
Alice Lex-Nerlinger
Untitled c.1926, Photo collage,
21.2 × 8.1, Galerie Berinson,
Berlin

Fig.29 (right)
Alice Lex-Nerlinger
Work! Work! Work! 1928,
Photogram, 37 × 83,
Academy of Arts, Berlin

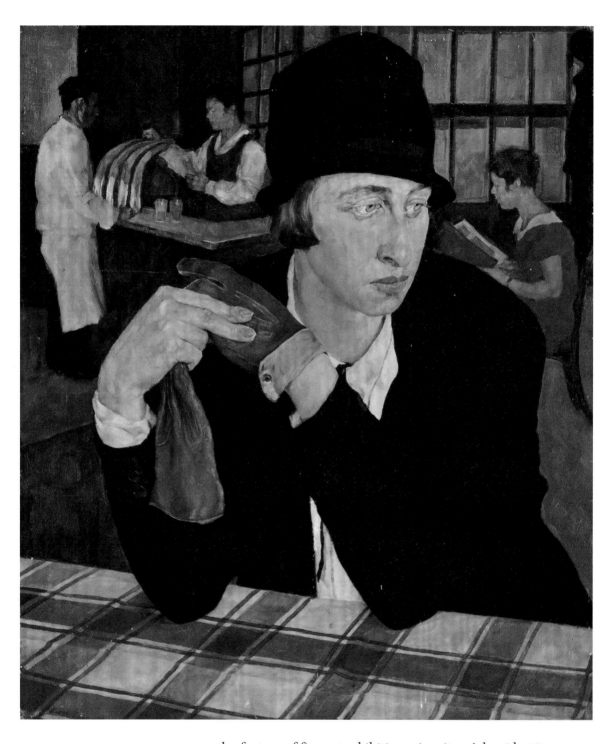

Fig.30
Lotte Laserstein
In the Tavern 1927
Oil on panel, 54 × 46,
Private collection

a regular feature of fine art exhibitions. As a 'type', her identity was
fluid and mobile. Her symbolic function ranged from role model
to scapegoat; an active agent seeking sexual, economic and political
emancipation for her generation *and* an empty sign constructed by
the media to bolster advertising campaigns in a new age of rationalised
production and American-inspired commodity culture. As a self-identified
'Neue Frau' of the mid to late 1920s, Lotte Laserstein's painterly

explorations of such media constructions demonstrated an implicit acknowledgement of their power, but also a subtle interrogation of them. Her oeuvre drew heavily on the iconic tropes of metropolitan modernity: fashionable new women, androgynes, journalists, tennis players, motorbike riders – all identifiable visual types connotative of the era's media-saturated consumer economy. Yet a painting like *In the Tavern* 1927 (fig.30) differs markedly from works such as Otto Dix's *Portrait of the Journalist Sylvia von Harden* 1926 or Edward Burra's *Snack Bar* 1930 (no.94) in its overall conception and mood. Burra's barman seems to revel in his slicing of the fleshy pink ham whilst sneaking a furtive glance at the glamorous female customer consuming her snack; a menacing air of sexual tension pervades the scene. Burra, Dix and George Grosz all use satire with excoriating effect in their depictions of urban types, whereas Laserstein shows her women in self-absorbed contemplation, independent of a masculine gaze. *In the Tavern* depicts a public space for women to inhabit not as sexual commodities but as independent people: customers removing gloves and reading the menu, staff pouring drinks. Yet if positive possibilities for creative women seemed to be part of the elusive promise of happiness during the 1920s and 1930s, the enjoyment was bitter-sweet. By 1933 Laserstein, a Jew, was no longer allowed to publicly exhibit her work and by 1937 she was exiled from her native Germany for good. The project of remaking society after the First World War was a complex entanglement of competing discourses and gendered divisions. No matter how much the popular press swept aside images of broken soldiers with maimed faces to make way for the figure of the ideal warrior and the new woman, the illusions of peacetime stability were extremely short-lived. **DP**

1 For more information and statistics about the number of war-wounded, see Joanna Bourke, *Dismembering the Male: Men's Bodies, Britain and the Great War*, London 1996; Deborah Cohen, *The War Come Home: Disabled Veterans in Britain and Germany, 1914–1939*, Berkeley, 2001; and Heather R. Perry, *Recycling the Disabled: Army, Medicine and Modernity in WW1 Germany*, Manchester 2014.

2 For more details see Suzannah Biernoff, 'Flesh Poems: Henry Tonks and the Art of Surgery', *Visual Culture in Britain*, vol.11, no.1, March 2010, pp.26–7; and Marjorie Gehhardt, *The Men with Broken Faces: Gueules Cassées of the First World War*, Oxford 2015.

3 For a more in-depth analysis of Tonks' portraits, see Emma Chambers, 'Fragmented Identities: Reading Subjectivity in Henry Tonks' Surgical Portraits', *Art History*, vol.32, no.3, June 2009, pp.578–607.

4 Hans Kinkel, 'Begegnung mit Otto Dix', *Stuttgarter Zeitung*, 30 Nov. 1961. Cited in Dietrich Schubert, 'Death in the Trench: The Death of the Portrait?' in Olaf Peters (ed.), *Otto Dix*, New York/Munich 2010, p.37.

5 Otto Dix cited in Diether Schmidt, *Otto Dix im Selbstbildnis*, Berlin, 1981, p.280.

6 See Anne Marno, 'The Etching Series *Der Krieg*' in Susanne Meyer-Büser (ed.), *Otto Dix – der böse Blick*, Düsseldorf/ Munich 2017, p.186.

7 Ann Murray, 'A War of Images: Otto Dix and the Myth of the War Experience' in *Aigne*, no.5, 2014, p.61.

8 Marno 2017, p.184.

9 Hal Foster, 'A Bashed Ego' in *Prosthetic Gods*, Massachusetts 2004, p.151. In the passage that follows I translate the title of Heinrich Hoerle's 'Krüppelmappe' literally as 'Cripple Portfolio' in keeping with the historical usage of a term that is unacceptable today. It was a term that Hoerle later abandoned.

10 Alice Lex-Nerlinger 'Erinnerungen' in Elspeth Moortgat (ed.), *Alice Lex-Nerlinger: Fotomonteurin und Malerin*, Berlin 2016, p.100.

11 Alice Lex-Nerlinger cited in Rachel Epp Buller, 'Alice Lex' in Moortgat 2016, p.155.

Imagining Post-war Society

76

76
Otto Dix
Working-Class Boy
1920
Oil paint on canvas

77
George Grosz
Grey Day 1921
Oil paint on canvas

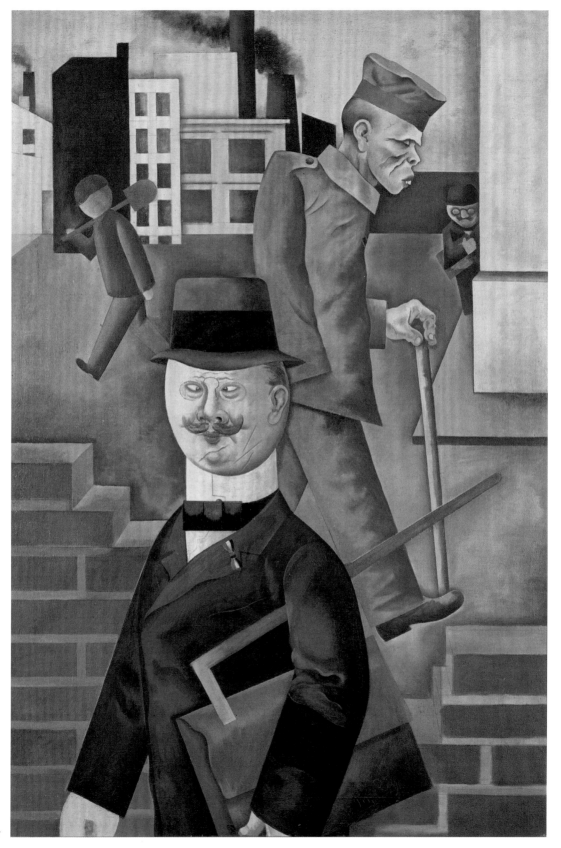

78
C.R.W. Nevinson
He Gained a Fortune
but he Gave a Son 1918
Oil paint on canvas

79
Heinrich Maria
Davringhausen
The Profiteer 1920–1
Oil paint on canvas

78

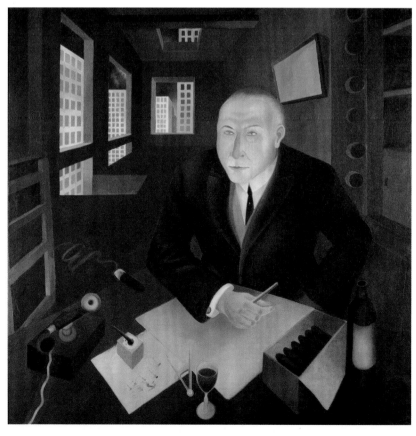

79

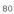

80
Heinrich Hoerle
Factory Worker c.1925
Oil paint, charcoal
and crayon on vellum
on wood

81
Wilhelm Lachnit
Worker with Machine
1924–8
Oil paint on wood

82
Marcel Gromaire
Labourers 1927
Oil paint on canvas

83
Clive Branson
Portrait of a Worker c.1930
Oil paint on canvas

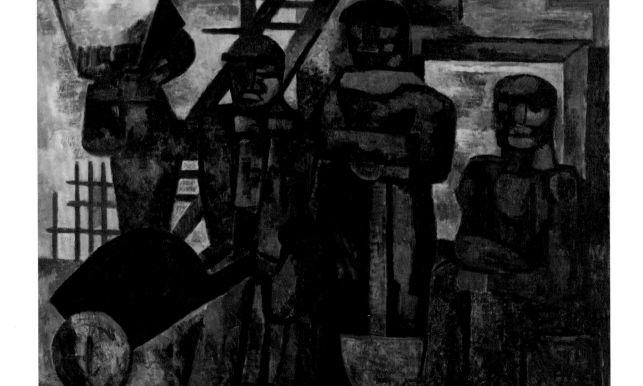

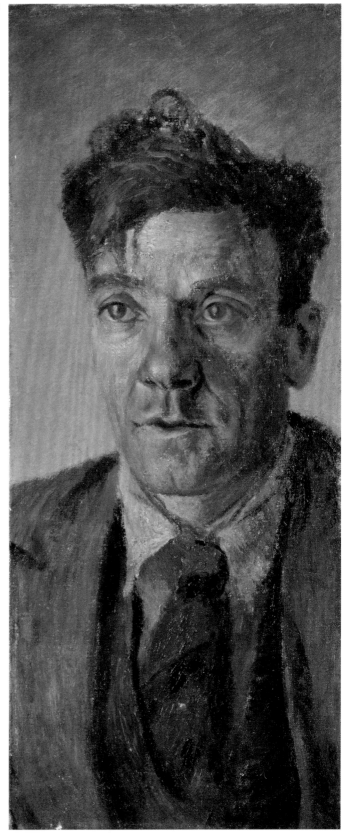

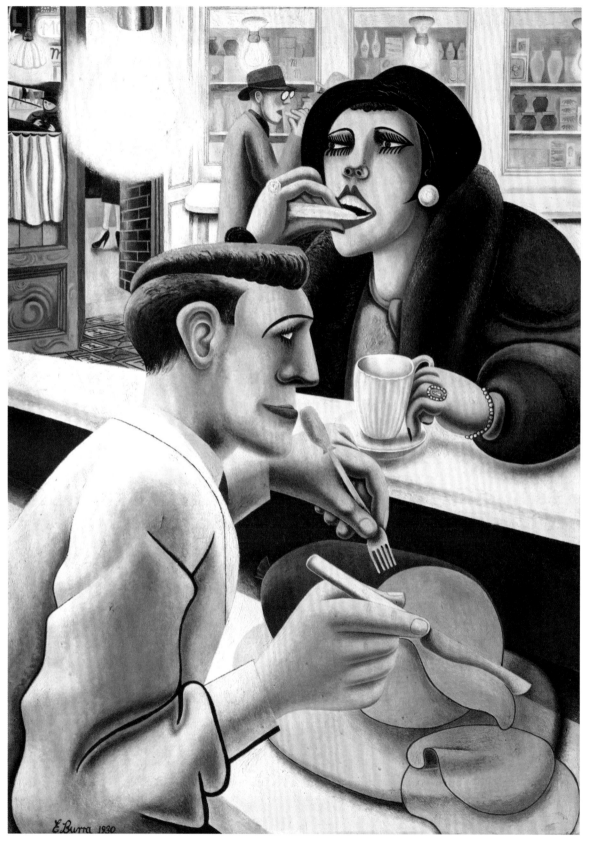

84

E. Burra 1930

110

84
Edward Burra
The Snack Bar 1930
Oil paint on canvas

85
William Roberts
*The Jazz Club
(The Dance Party)* 1923
Oil paint on canvas

85

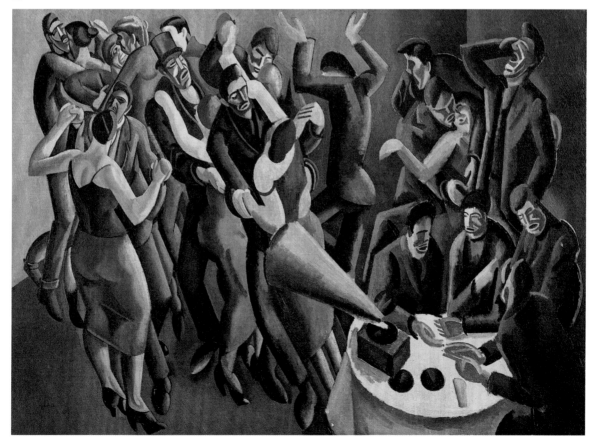

87

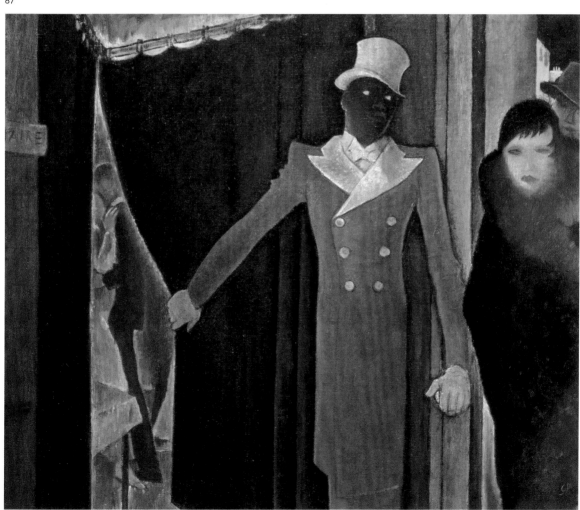

89

89
Fernand Léger
Discs in the City 1920
Oil paint on canvas

88
Oskar Schlemmer
Abstract Figure 1921
Bronze

90
Oskar Nerlinger
*Radio Tower and
Elevated Railway* 1929
Casein tempera
on canvas

91
C.R W. Nevinson
*The Soul of the Soulless
City ('New York –
an Abstraction')* 1920
Oil paint on canvas

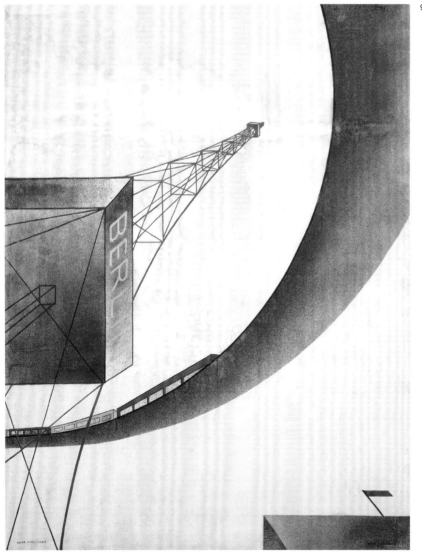

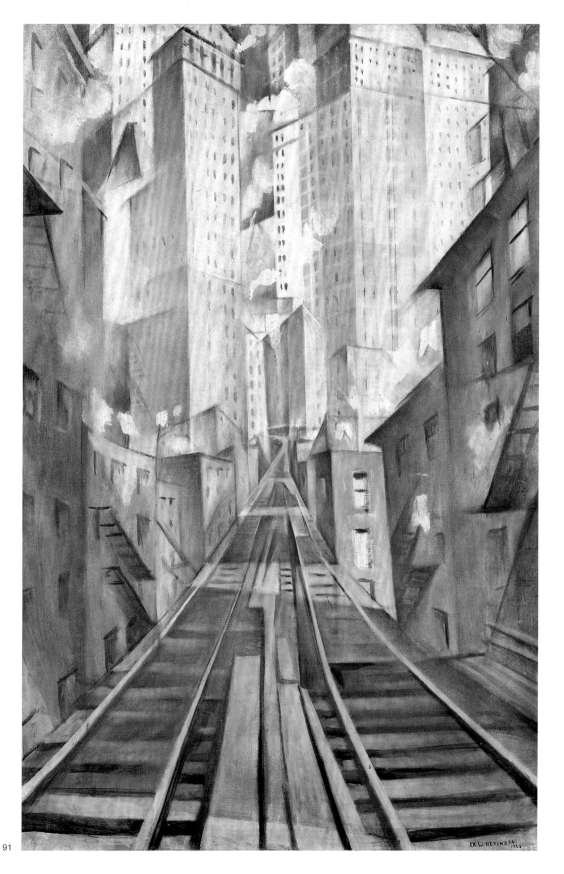

91

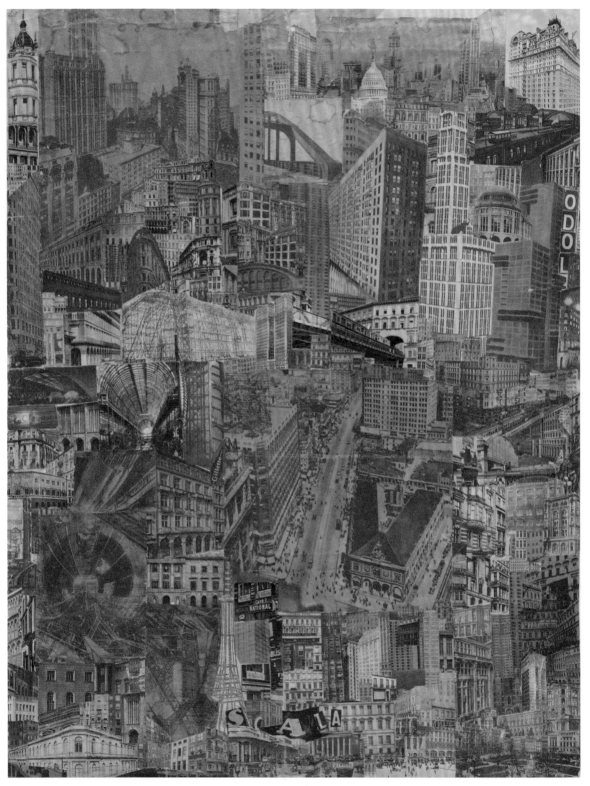

92

92
Paul Citroen
Metropolis 1923
Photomontage on paper

93
Oskar Nerlinger
*Radio Tower
and Worker* c.1924
Photomontage

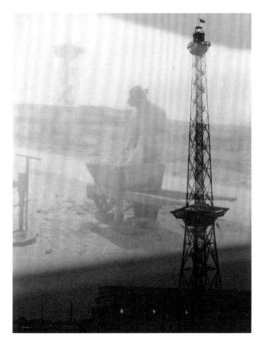

93

94

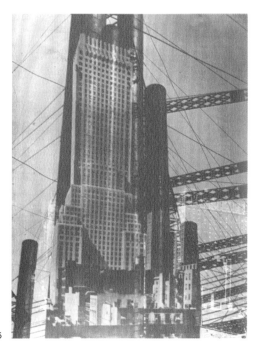

95

94
Sasha and Cami Stone
*Berlin, Bird's Eye
View, Radio Tower
Restaurant* 1928
Photograph, gelatin
silver print on paper,
Galerie Berinson, Berlin

95
El Lissitzky
*Study for the Cover of
Richard Neutra's Book
'Amerika'* 1929
Photograph, gelatin
silver print on paper

96

97

96
Germaine Krull
Métal 1928
Photo-etching on paper,
from a portfolio of 64
plates

97
Albert Renger–Patzsch
Untitled 1925–6
Photograph,
gelatin silver print
on paper

98
Oskar Nerlinger
"Quick another Bite"
1928
Photomontage with
tempera

99
Alice Lex-Nerlinger
*Man with Pneumatic
Drill* 1930
Photogram

100
Fernand Léger
Mechanical Ballet
1924
35 mm film

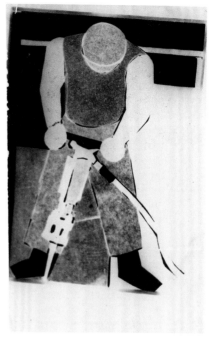

99

98

100

Chronology 1914–1932

Artists who served in
British army include:

Charles Sargeant Jagger
Eric Kennington
Wyndham Lewis
Henry Moore
John and Paul Nash
C.R.W. Nevinson
William Roberts
Stanley Spencer

Artists who served in
French army include:

Georges Braque
André Derain
Roger de la Fresnaye
Paul Jouve
Fernand Léger
André Masson

Artists who served in
German army include:

Ernst Barlach
Max Beckmann
Otto Dix
Max Ernst
George Grosz
Oskar Schlemmer

1914
20 June: Vorticist journal
*BLAST: The Review of the Great
English Vortex* published

28 June: Assassination of
Archduke Franz Ferdinand of
Austria and his wife

1–3 August: Germany declares
war on Russia and France

2 August: Picasso accompanies
Braque and Derain to Avignon
station, where his friends depart
for military service

4 August: Britain declares war
on Germany

5–12 September: First Battle of
the Marne halts German advance
on Paris

October: Kollwitz's son Peter dies
while serving in Flanders

1915
22 April: German army first
uses lethal chlorine gas at Ypres,
West Flanders

11 May: Braque receives severe
wound to head in the Second
Battle of Artois, northern France

5 June: Sculptor Henri Gaudier-
Brzeska killed in the trenches

July. Special 'War Number'
of *BLAST* published

1916
January: National Committee
for the Care of Soldiers' Graves
founded in Britain

21 February – 16 December: Battle
of Verdun, the longest battle on
the Western Front in north-eastern
France

2 March: Military conscription
in Britain extended to men from
18 to 41 years old

17 March: Guillaume Apollinaire
evacuated to Val-de-Grâce
Hospital with head wound

April: Mass demonstrations
against conscription in Trafalgar
Square, London

24–29 April: Easter Rising in
Dublin against British rule

1 July – 18 November: Battle of
the Somme, northern France

November: Moholy-Nagy wounded
while serving in Austro-Hungarian
army; Léger gassed
while stationed at Verdun

1917
January–February: Grosz
wounded and transferred to
psychiatric hospital

April: German army film unit
begins to operate; Masson
receives bullet wound to chest
at Second Battle of the Aisne,
at Chemin des Dames

8 April: The United States declare
war on Germany

21 May: The Imperial War Graves
Commission founded in Britain

June: The Queen's Hospital in
Sidcup, south-east London, opens
as specialist unit for facial injuries

31 July – 10 November: Battle of
Passchendaele, West Flanders

15 September: Breton meets
Louis Aragon, both trainee
doctors, at Val-de-Grâce Hospital

November: American troops arrive
on the Western Front

October: Paul Nash (injured in
service that May) returns to the
Western Front as official war artist

The first portfolio of prints by
Grosz published in Berlin

1918
A worldwide flu epidemic takes hold

February: The British War
Memorials Committee founded

March: Nevinson's *Paths of Glory*
exhibited in London

March–August: Germany uses long-
range siege gun to bombard Paris

12 April: First German Dada
manifesto read at a Dada evening
in Berlin

15 July – 14 August: Germany's
defeat at Second Battle of
the Marne, near Reims

17 July: Murder of Russian Tzar
Nicholas II and his family

8 August: The Allies' Hundred
Days Offensive begins with Battle
of Amiens, northern France

4 October: German
government requests armistice
discussions with US President
Woodrow Wilson

11 November: Germany signs
Armistice at Compiège, northern
France, effective from 11am

Representation of the People Act
of Britain and Ireland gives right to
vote to women over age of 30 with
property qualification and all men
over age of 21

The British War Memorials
Committee commissions
a 'Hall of Remembrance'

The Decline of the West by Oswald
Spengler published in Germany

1919
5 January: The German Workers'
Party founded in Munich

15 January: Rosa Luxemburg and
Karl Liebknecht, leaders of
the German Communist Party,
murdered in Berlin

18 January: Paris Peace Conference
begins

19 January: Voting age in Germany
lowered from 25 to 20 and
women given equal voting rights

2 March: The Communist
International founded by
Vladimir Lenin

1 April: Bauhaus art school founded
in Weimar by Walter Gropius

28 June: Germany signs the
Treaty of Versailles

July: National events in Britain
and France to mark the signing
of the peace treaty

31 July 1919: Foundation of
the Weimar Republic

9 November: Abdication of
Wilhelm II, the last German Emperor

11 November: Thousands take part
in two-minute silence at the tempo-
rary Cenotaph, Whitehall, London

Film *J'Accuse* by Abel Gance
released in France

André Lhote describes
a 'call to order' in paintings by
Georges Braque

'The Spiritual Crisis' by Paul Valéry
published in Britain and France

1920
10 January: Foundation of
the League of Nations

12 May: A law censoring
films glorifying violence passed
in Germany

June – August: The First International Dada Fair in Berlin

11 November: A permanent Cenotaph unveiled in Whitehall, London. Ceremonies for the Unknown Soldier in London and Paris

Poems by Wilfred Owen published posthumously in Britain

The first public broadcasting stations set up in Britain and United States

Russian architect Vladimir Tatlin finishes model for the *Monument to the Third International*

Grosz's print portfolio *God with Us* published in Germany (banned 1921)

1921
January: Picasso exhibition, Leicester Galleries, London

10 December: Albert Einstein awarded the Nobel Prize in Physics

Women in Love by D.H. Lawrence published in Britain

The London Schedule of Payments sets Germany's reparation debts

1922
16 January: *A Pastoral Symphony* by Vaughan Williams first performed in London

20 September: Schlemmer's *The Triadic Ballet* premieres in Stuttgart

25 – 26 September: The Congress of Constructivists and Dadaists, Weimar

29 September: *Drums in the Night* by Bertold Brecht premieres in Berlin

14 November: Daily broadcasting by the BBC begins in London

The Waste Land by T.S. Eliot published in Britain and the United States

1923
The Ruhr region occupied by French and Belgian forces after Germany fails to make payments in coal and timber

27 April: *The Ego and the Id* by Sigmund Freud published in Vienna

Towards a New Architecture by Le Corbusier published in France (English trans. 1927)

Men Like Gods by H.G. Wells published in Britain

Sonnets to Orpheus and *Duino Elegie* by Rainer Maria Rilke published in Germany

Dix completes monumental painting *The Trench* (1920 – 3; now lost)

Autobiography of Henry Ford, developer of assembly line production, published in Germany

1924
21 January: Death of Lenin

12 February: George Gershwin's *Rhapsody in Blue* premieres in New York

25 February: *Five Piano Pieces, Op 25* by Arnold Schoenberg premieres in Vienna

13 June: The Red Group of Communist artists (including Grosz, Heartfield, Dix, Schlichter and Griebel) founded in Berlin

15 October: Breton's *Surrealist Manifesto* published in France

A Passage to India by E.M. Forster published in Britain

Dix's *The War* etchings are published Germany

Kollwitz's *War* woodcuts exhibited at the International Anti-War Museum, Berlin

1925
April – October: *International Exhibition of Modern Decorative and Industrial Arts*, Paris

14 June: *The New Objectivity* exhibition, Kunsthalle Mannheim

July: *Mein Kampf* by Adolf Hitler published in Germany

18 October: Jagger's Royal Artillery memorial unveiled at Hyde Park Corner, London

The Great Gatsby by F. Scott Fitzgerald published in the United States

Mrs Dalloway by Virginia Woolf published in Britain

1926
10 January: Film *Metropolis* by Fritz Lang released in Germany

26 January: The television system first demonstrated in London

May – November: Miners' Strike and General Strike in Britain

8 September: Germany admitted to the League of Nation

Spencer begins work in situ on murals for Sandham Memorial Chapel, Burghclere, Hampshire (completed 1932)

Peak unemployment in Germany

A Call to Order by Jean Cocteau published in France

1927
24 July: Menin Gate memorial to the missing unveiled in Ypres, West Flanders

7 October: Neuve-Chapelle Indian Memorial unveiled in northern France

To the Lighthouse by Virginia Woolf published in Britain

Film *The Jazz Singer*, starring Al Jolson, released in the United States

Film *Napoléon*, by Abel Gance, released in France

1928
31 August: *The Threepenny Opera* by Bertold Brecht and Elizabeth Hauptmann premieres in Berlin

8 November: Docudrama film *Verdun: Visions of History* released in France

Breton's Surrealist novel *Nadja* published in France

1929
29 January: *All Quiet on the Western Front* by Erich Maria Remarque published in Germany

April: First issue of *Documents*, edited by Georges Bataille, published in France

18 May-17 June: *Film and Foto* exhibition of German Association of Craftsmen, Stuttgart, Germany

24 October: 'Black Friday' on the New York Stock Exchange marks the beginning of the Great Depression

November: Opening of the Museum of Modern Art, New York

15 December: Breton's 'Second Manifesto of Surrealism' published in France

1930
26 May: Briton Amy Johnson completes solo flight from Britain to Australia

21 April: Film adaptation of *All Quiet on the Western Front* released in the US and Britain

Vile Bodies (originally 'Bright Young Things') by Evelyn Waugh published in Britain

1931
Completion of the Empire State Building in New York

25 April – 31 May: *Photomontage* exhibition, State Museums of Berlin

June: The North German Wool Carding Company goes bankrupt, triggering withdrawals from German industrial banks

December: Film adaptation of *All Quiet on the Western Front* released in Berlin and banned soon after

1932
January: *Piano Concerto for the Left Hand in D major* by Maurice Ravel premieres in Vienna

9 February – 23 March: *Modern Architecture: International Exhibition*, Museum of Modern Art, New York

16 June-9 July: Resetting of Germany's reparation payments

31 July: Arras Memorial unveiled in Faubourg d'Amiens British Cemetery, northern France

31 July: Hermann Göring, a former fighter pilot, becomes President of the Reichstag

1 August: Thiepval Memorial to the Missing of the Somme unveiled in Picardy, France

October: David Jones suffers a nervous breakdown while working on *In Parenthesis* (pub. 1937)

8 November: Democrat Franklin D Roosevelt elected President of the United States

Brave New World by Aldous Huxley published in Britain

Little Man, What Now? by Hans Fallada published in Germany

List of Exhibited Works

Information is correct at time of going to press but is subject to change.

Pierre Antony-Thouret
Reims after the War 1919,
published 1927
Portfolio of 127 heliogravure
plates, 5 displayed
each 32.5 × 49
Private collection (not illustrated)

Ernst Barlach 1870–1938
The Floating One 1927, cast 1987
Bronze, 213 × 74 × 68
Loan from the Kulturring der
Schleswig-Holsteinischen
Wirtschaft in der Stiftug/
Schelswig-Holsteinische
Landesmuseum Schloss Gottorf,
Schleswig, Germany (p.37)

Max Beckmann 1884–1950
Hell 1919
Portfolio of 10 lithographs on
paper, 6 displayed, each 87 × 61
National Galleries of Scotland,
Edinburgh. Purchased 1981.
Plate 2: *The Way Home* (p.70)

Albert Birkle 1900–1986
*Cross Shouldering
(Friedrichstrasse)* 1924
Oil paint on canvas, 96.5 × 217
The George Economou Collection
(p.87)

Antoine Bourdelle 1861–1929
France 1923, cast 1977
Bronze, 133.8 × 33 × 20.5
Musée Bourdelle, Paris, France
(p.33)

Clive Branson 1907–1944
Portrait of a Worker c.1930
Oil paint on canvas, 61 × 25 × 1.6
Tate. Bequeathed by Noreen
Branson 2004 (p.109)

Georges Braque 1882–1963
Bather 1925
Oil paint on board, 67 × 54.3
Tate. Bequeathed by C. Frank
Stoop 1933 (p.91)

Dorothy Brett 1883–1977
War Widows 1916
Oil paint on canvas, 103 × 103
Catherine Shuckburgh (p.92)

Edward Burra 1905–1976
Keep your Head 1930
Printed papers and graphite on
paper, 59.7 × 54.3
Tate. Purchased 1971

Les Folies de Belleville 1928
Gouache on paper, 63.5 × 51
Private collection
(Not illustrated)
The Eruption of Vesuvius 1930
Collage and watercolour on paper
50.8 × 39.4
Private collection, courtesy of
Austin Desmond Fine Art (p.63)

The Snack Bar 1930
Oil paint on canvas, 76.2 × 55.9
Tate. Purchased 1980 (p.110)

Rosine Cahen 1857–1933
The Amputees' Workshop 1918
Charcoal on paper, 32 × 25
Private collection (p.52)

Villemin Hospital (2 January 1918)
1918
Charcoal and pastel on paper,
26.5 × 21.5
Private collection
(Not illustrated)

Richard Carline 1896–1980
*Mine Craters at Albert Seen from
an Aeroplane* 1918
Oil paint on canvas, 42.4 × 35.2
IWM (Imperial War Museums),
London (p.29)

Louis François Carli 1872–1957
*Psychoneurotic camptocormia
observed during the war* 1917
Patinated plaster, 31 × 32 × 18
Musée du Service de santé des
armées. Val-de-Grâce, Paris
(Not illustrated)

Paul Citroen 1896–1983
Metropolis 1923
Collage and photomontage on
paper, 76.1 × 58.4
Leiden University Library,
The Netherlands (p.118)

George Clausen 1852–1944
The Road, Winter Morning
exhibited 1923
Oil paint on canvas, 50.8 × 61
Tate. Presented by the Trustees of
the Chantrey Bequest 1923.
(Not illustrated)

**Heinrich Maria Davringhausen
1894–1970**
The Profiteer 1920–1
Oil paint on canvas, 120 × 120
Stiftung Museum Kunstpalast,
Düsseldorf, Germany (p.106)

André Derain 1880–1954
L'Italienne 1920–24
Oil paint on canvas on plywood,
93 × 74
National Museums Liverpool,
Walker Art Gallery (p.90)

Otto Dix 1891–1969
Card Players 1920
Drypoint on paper, 33 × 28.4
The George Economou Collection
(Not illustrated)

Match-Seller 1920
Drypoint and etching on paper,
25.9 × 30
The George Economou Collection
(Not illustrated)

War Cripples 1920
From 'Radierwerk I'
Drypoint on paper, 25.4 × 36.9
The George Economou Collection
(p.60)

Working-Class Boy 1920
Oil paint on canvas, 86.8 × 40.5
Kunstmuseum Stuttgart, Germany
(p.104)

*Prostitute and Disabled War
Veteran. Two Victims of Capitalism*
1923
Ink on cardboard, 46.9 × 37.3
LWL-Museum für Kunst und Kultur/
Westfälisches Landesmuseum,
Münster, Germany (p.59)

The War (Der Krieg) 1923–4
Portfolio of 50 etchings, aquatint,
and drypoint prints on paper,
13 displayed
Dimensions variable
The George Economou Collection
Dead Man (St. Clément) (p.96)

Shock Troops Advance under Gas
(p.70)

Jacob Epstein 1800–1959
Torso in Metal from 'The Rock Drill'
1913–4
Bronze, 70.5 × 58.4 × 44.5
Tate. Purchased 1960 (p.23)

**Max Ernst 1891–1976
with Hans Arp 1886–1966**
Here Everything is Still Floating
1920
Photocollage on card, 29.4 × 35.7
Stiftung Arp e.V., Rolandswerth/
Berlin (p.66)

Anatomy 1921
Postcard, 14 × 9
Stiftung Arp e.V.,
Rolandswerth/Berlin (p.66)

Max Ernst
Celebes 1921
Oil paint on canvas, 125.4 × 107.9
Tate. Purchased 1975 (p.67)

Untitled 1921
Postcard, 8.7 × 13.7
Stiftung Arp e.V., Rolandswerth/
Berlin, (Not illustrated)

Zambesi Land 1921
Photocollage on postcard, 9 × 14
Stiftung Arp e.V., Rolandswerth/
Berlin (Not illustrated)

Conrad Felixmüller 1897–1977
Soldier in the Madhouse I 1919
Lithograph on paper, 38 × 31
Von der Heydt-Museum Wuppertal,
Germany (Not illustrated)

Soldier in the Madhouse II 1919
Lithograph on paper, 40.4 × 30.7
Von der Heydt-Museum Wuppertal,
Germany (Not illustrated)

Meredith Frampton 1894–1984
Marguerite Kelsey 1928
Oil paint on canvas, 120.8 × 141.2
Tate. Presented by the Friends of
the Tate Gallery 1982 (p.94)

**Roger de la Fresnaye
1885–1925**
The Herdsman 1921
Oil paint on wood, 45.5 × 55
Musée d'art moderne de Troyes,
collections nationales Pierre et
Denise Lévy (p.82)

Eric Gill 1882–1940
Mankind 1927–8
Hoptonwood stone,
241.3 × 61 × 45.7
Tate. Purchased with assistance
from Eric Kennington, the
Knapping Fund and subscribers
1938
(Not illustrated)

Otto Griebel 1895–1972
The International 1928–30,
copy 1989 by
Ingrid Griebel–Zietlow
Oil paint on canvas, 124 × 182
Stiftung Deutsches Historisches
Museum, Berlin
(original illustrated p.10)

Marcel Gromaire 1892–1971
The Reaper 1924
Oil paint on canvas, 100 × 81
Musée d'Art Moderne de la Ville de
Paris, France (Not illustrated)

War 1925
Oil paint on canvas, 127.6 × 97.8
Musée d'Art Moderne de la Ville de
Paris, France (p.39)

Labourers 1927
Oil paint on canvas, 81 × 100
Musée d'Art Moderne de la
Ville de Paris, France (p.108)

George Grosz 1893–1959
Blind Man 1923
Graphite on paper, 58.8 × 40
Von der Heydt-Museum Wuppertal,
Germany (p.56)

*'Are we not fit for the League
of Nations'* 1919
Ink on paper, 56 × 38.4
Staatsgalerie Stuttgart,
Graphische Sammlung, acquired
1924 (p.57)

*'Daum' marries her pedantic
automaton 'George' in May 1920,
John Heartfield is very glad of it
(Meta–mech. constr. after Prof. R.
Hausmann)* 1920
Watercolour, graphite, ink and
collage on cardboard, 40 × 30.2
Berlinische Galerie –
Landesmuseum für Moderne
Kunst, Fotografie und Architektur
(p.62)

Grey Day 1921
Oil paint on canvas, 115 × 80
Staatliche Museen zu Berlin,
Nationalgalerie. Acquired in 1954
by the state of Berlin (p.105)

Toads of Property 1920
Ink on paper, 52.7 × 41.1
National Galleries of Scotland,
Edinburgh. Purchased 1979
(Not illustrated)

**George Grosz 1893–1959 and
John Heartfield 1891–1968**
*The Petit–Bourgeois Philistine
Heartfield Gone Wild (Electro–
Mechanical Tatlin Sculpture)*
1920, reconstructed 1988 by
Michael Sellman
Tailor's dummy, revolver, bell,
knife and fork, letter 'C',
number '27', dentures, black eagle
medal, EK II, Osram bulb
130 × 45 × 45
Berlinische Galerie –
Landesmuseum für Moderne
Kunst, Fotografie und Architektur
(p.61)

Kurt Günther 1893–1955
The Radionist 1927
Tempera on wood, 55 × 49
Staatliche Museen zu Berlin,
Nationalgalerie (Not illustrated)

Cuthbert Hamilton 1885–1959
Reconstruction 1919–20
Graphite, crayon and gouache on
paper, 55.9 × 41.9
Tate. Purchased 1965.
(Not illustrated)

Sella Hasse 1878–1963
*One-armed War-blinded Man
at the Machine* 1919
Linocut on paper, 50.4 × 39.1
Stiftung Deutsches Historisches
Museum, Berlin, Germany (p.52)

Hannah Höch 1889–1978
Dada-Rundschau 1919
Collage, gouache and watercolour
on cardboard, 43.7 × 34.5
Berlinische Galerie –
Landesmuseum für Moderne
Kunst, Fotografie und Architektur
(p.64)

Heinrich Hoerle 1895–1936
Factory Worker c.1925
Oil paint, charcoal and crayon on
vellum on wood, 39.5 × 25.5
The George Economou Collection
(p.107)

Cripple Portfolio 1920
Portfolio of 12 lithographs on
paper, 4 displayed, each 64 × 51
August Sander Stiftung, Cologne,
Germany.
Plate 7: *The Man with the
Wooden Leg Dreams* (p.54)

Factory Worker c.1925
Oil paint, charcoal and crayon on
vellum on wood, 39.5 × 25.5
The George Economou Collection
(p.107)

**Charles Sargeant Jagger
1885–1934**
No Man's Land 1919–20
Bronze, 126.4 × 307.5 × 9
Tate. Presented by the Council of
British School at Rome 1923 (p.34)

Driver 1921–5
Bronze, 88 × 74 × 31
The Worshipful Company of
Founders (p.35)

Soldier Reading a Letter 1921–2
Bronze, 78 × 45.5
The Worshipful Company of
Founders (Not illustrated)

David Jones 1895–1974
The Garden Enclosed 1924
Oil paint on wood, 35.6 × 29.8
Tate. Presented by the Trustees
of the Chantrey Bequest 1975.
(Not illustrated)

Paul Jouve 1878–1973
*Grave of a Serbian soldier at
Kenali 1917* 1917
Chinese ink, gouache and graphite
on paper, 34 × 26.9
Musée de l'Armée, Paris, France
(p.26)

Eric Kennington 1888–1960
*Maquette for the Soissons
Memorial for the Missing* 1927
Plaster, 72 × 58.4 × 32
IWM (Imperial War Museums),
London, (Not illustrated)

Winifred Knights 1899–1947
The Deluge 1920
Oil paint on canvas, 152.9 × 183.5
Tate. Purchased with assistance
from the Friends of the Tate
Gallery 1989 (p.86)

Käthe Kollwitz 1867–1945
*Design for 'The Parents'
monument, Roggeveld military
cemetery, Belgium* 1927
Ink on paper, 21 × 17.5
Akademie der Künste, Berlin,
Käthe-Kollwitz-Archiv, Nr.9 (p.36)

*Sketch for 'The Parents'
Monument for Roggeveld* 1931
Wash on paper, 50 × 65.2
E.W.K. Bern (Not illustrated)

*Two sketches for 'The Parents'
monument, Roggeveld military
cemetery, Belgium* 1924
Ink on paper, 21 × 17.5
Akademie der Künste, Berlin,
Käthe-Kollwitz-Archiv, Nr.8
(Not illustrated)

War (Der Krieg) 1921–2
Portfolio of 7 woodcut prints on
paper, all displayed
Dimensions variable
Plate 3: *The Parents* (p.71)

Germaine Krull 1897–1985
Métal 1928
Portfolio of 64 photo–etchings on
paper, 2 displayed
29 × 22.5 each
Tate Library and Archive
Plate 44 (p.120)

Wilhelm Lachnit 1899–1962
Worker with Machine 1924–8
Oil paint on wood, 50 × 52
Staatliche Museen zu Berlin,
Nationalgalerie (p.107)

Fernand Léger 1881–1955
Discs in the City 1920
Oil paint on canvas, 130 × 162
Centre Pompidou, Paris
Musée national d'art moderne/
Centre de création industrielle
Donation Louise et Michel Leiris,
1984, no. inv.: AM 1984-603.
(p.115)

Mechanical Ballet 1924
35 mm film
Musée national d'art moderne/
Centre Pompidou, Paris, France
(p.121)

Wilhelm Lehmbruck 1881–1919
The Fallen Man 1915, cast 1916
Bronze, 80.5 × 240 × 83.5
Lehmbruck Estate (p.22)

Franz Lenk 1898–1968
Old Military 1930
Oil paint on canvas on wood,
114 × 94.5
The George Economou Collection
(p.85)

Marc Leriche 1885–1918
*Astasia–abasia psychogenic
tremor* 1917
Plaster, 43 × 18 × 13
Musée du Service de santé des
armées. Val-de-Grâce, Paris
(Not illustrated)

The Reaper 1917
Plaster, paint and wood 46 × 30 × 30
Musée du Service de santé des
armées. Val-de-Grâce, Paris (p.53)

Alice Lex-Nerlinger 1893–1975
Work, Work, Work c.1928
Photograph, gelatin silver print
on paper, 19.9 × 16.7
Akademie der Künste, Berlin,
Kunstsammlung, 2820
(Not illustrated)

Cart Pusher 1930
Photograph, silver gelatin print
on paper, 30 × 39.2
Akademie der Künste, Berlin,
Kunstsammlung, 2930
(Not illustrated)

*Man with Air Hammer
(Motif for 'Poor and Rich')* 1930
Photograph, gelatin silver print
on paper, 23.7 × 14.8
Akademie der Künste, Berlin,
Kunstsammlung, 2887
(Not illustrated)

*Rods of a Steam Engine
(Motif for 'For Profit')* c.1930
Photograph, gelatin silver print
on paper, 12 × 17.9
Akademie der Künste, Berlin,
Kunstsammlung, 2894
(Not illustrated)

Work! Work! Work! c.1931
Photograph, gelatin silver print
on paper, 18.1 × 24
Akademie der Künste, Berlin,
Kunstsammlung, 6076
(Not illustrated)

El Lissitzky 1890–1941
*Study for the Cover of Richard
Neutra's Book 'Amerika'* 1929
Photograph, gelatin silver print
on paper, 25.7 × 19.4
Jack Kirkland Collection,
Nottingham (p.119)

Jeanne Mammen 1890–1976
Valeska Gert 1928–9
Oil paint on canvas, 60 × 44
Berlinische Galerie –
Landesmuseum für Moderne
Kunst, Fotografie und Architektur
(p.112)

Aristide Maillol 1861–1944
Venus with a Necklace c.1918–28, cast 1930
Bronze, 175.3 × 61 × 40
Tate. Presented by the
Contemporary Art Society 1931
(Not illustrated)

Werner Mantz 1901–1983
*Sinn Department Store
(Architect Professor Bruno Paul,
Berlin)* c.1930
Photograph, gelatin silver print
on paper, 23.1 × 16.9
Jack Kirkland Collection,
Nottingham, (Not illustrated)

André Mare 1885–1932
*Decorative scheme for the Victory
celebrations 14 July 1919* 1919
Ink and wash on paper,
25.4 × 32.5
Musée Carnavalet – Histoire de
Paris, France (Not illustrated)
*Decorative scheme for the Victory
celebrations 14 July 1919* 1919
Crayon on tracing paper,
45.5 × 28.3
Musée Carnavalet – Histoire de
Paris, France. (p.32)

*Transportation of the monument
for the Victory celebrations* 1919
Charcoal with gouache highlights
on paper
30.3 × 47.2
Musée Carnavalet – Histoire de
Paris, France (Not illustrated)

Survivors 1929
Oil paint on canvas, 40 × 32
Bibliothèque de Documentation
Internationale Contemporaine
(BDIC) (p.55)

André Masson 1896–1987
La route de Picardie 1924
Oil paint on canvas, 116.4 × 73.5
Centre Pompidou, Paris. Musée
national d'art moderne/Centre de
création industrielle. Purchased
1983 (p.68)

Lancelot 1927
Oil paint and sand on canvas,
46 × 21.5
Centre Pompidou, Paris. Musée
National d'Art Moderne/Centre
de création industrielle. Donation
Louise et Michel Leiris, 1984 (p.69)

Henry Moore 1898–1986
Standing Woman 1924
Portland stone, 56.5 × 13.7 × 11.6
Tate. Lent from a private collection
1994 (Not illustrated)

Luc–Albert Moreau 1882–1948
*Chemin des Dames Assault,
October 1917* 1918
Oil paint on canvas, 98 × 81
Bibliothèque de Documentation
Internationale Contemporaine (BDIC)
(Not illustrated)

John Nash 1893–1977
The Cornfield 1918
Oil paint on canvas, 68.6 × 76.2
Tate. Presented by the
Contemporary Art Society 1952
(p.80)

Paul Nash 1889–1946
Landscape at Iden 1929
Oil paint on canvas, 69.8 × 90.8
Tate. Presented by the Daily Mail
1927 (p.84)

Wire 1918–9
Watercolour, chalk and ink on
paper, 48.6 × 63.5
IWM (Imperial War Museums),
London (p.25)

Oskar Nerlinger 1893–1969
Radio Tower and Worker c.1924
Photomontage, 27.2 × 20.2
Akademie der Künste, Berlin
(p.119)

"Quick another bite" 1928
Photomontage with tempera
30.8 × 28
Akademie der Künste, Berlin
(p.121)

*Radio Tower and Elevated
Railway* 1929
Casein tempera on canvas 105 × 80
Staatliche Museen zu Berlin,
Nationalgalerie (p.116)

C.R.W. Nevinson 1889–1946
Ypres After the First Bombardment
1916
Oil paint on canvas,
99.1 × 124.8 × 7.3
Museums Sheffield (p.28)

Paths of Glory 1917
Oil paint on canvas 45.7 × 60.9
IWM (Imperial War Museums),
London (p.27)

*He Gained a Fortune but he Gave
a Son* 1918
Oil paint on canvas, 41 × 50.8
University of Hull Art Collection
(p.106)

*The Soul of the Soulless City
('New York – an Abstraction')* 1920
Oil paint on canvas, 91.5 × 60.8
Tate. Presented by the Patrons of
British Art through the Tate Gallery
Foundation 1998 (p.117)

Karel Niestrath 1896–1971
War Cripple with Child 1925
Bronze, 23.1 × 18.8 × 20.3
Stiftung Deutsches Historisches
Museum, Berlin, Germany
(Not illustrated)

William Orpen 1878–1931
A Grave in a Trench 1917
Oil paint on canvas, 76.2 × 63.5
IWM (Imperial War Museums),
London (p.24)

Blown Up 1917
Graphite and watercolour on
paper, 58.4 × 43.1
IWM (Imperial War Museums),
London (p.50)

Zonnebeke 1918
Oil paint on canvas, 63.5 × 76.2
Tate. Presented by Diana Olivier
2000 (Not illustrated)

*To the Unknown British Soldier in
France* 1921–8
Oil paint on canvas, 154.2 × 128.9
IWM (Imperial War Museums),
London (p.31)

**Glyn Warren Philpot
1884–1937**
Entrance to the Tagada 1931
Oil paint on canvas, 50.2 × 61.3
By kind permission of The Lord
Bamford DL. (p.113)

Pablo Picasso 1881–1973
Family by the Seashore 1922
Oil paint on wood, 17.6 × 20.2
Musée Picasso, Paris, France (p.89)

Seated Woman in a Chemise
1923
Oil paint on canvas, 92.1 × 73
Tate. Bequeathed by C. Frank
Stoop 1933 (p.91)

Dod Procter 1892–1972
Morning 1926
Oil paint on canvas, 76.2 × 152.4
Tate
(p.94)

Curt Querner 1904–1976
Demonstration 1930
Oil paint on canvas, 87 × 66
Staatliche Museen zu Berlin,
National-galerie (Not illustrated)

Franz Radziwill 1895–1983
Morning at the Cemetery Wall
1927
Mixed media on textile support
80 × 99
Kunsthalle Mannheim, Germany
(Not illustrated)

**Albert Renger–Patzsch
1897–1966**
Study of machine gear c.1925–8
Photograph, gelatin silver print on
paper, 23 × 17.2
Jack Kirkland Collection,
Nottingham (Not illustrated)

Untitled 1925–6
Photograph, gelatin silver print on
paper, 28 × 38.7
Jack Kirkland Collection,
Nottingham (p.120)

*Herrenwyck Blast Furnace Plant,
Lübeck* 1928
Photograph, gelatin silver print on
paper, 7.9 × 10.9
Jack Kirkland Collection,
Nottingham (Not illustrated)

William Roberts 1895–1980
A Shell Dump, France 1918
Oil paint on canvas, 182.8 × 317.5
IWM (Imperial War Museums),
London (p.29)

The Jazz Club (The Dance Party)
1923
Oil paint on canvas, 76.2 × 106.6
Leeds Museums and Gallery
(Leeds Art Gallery) (p.111)

Georges Rouault 1871–1958
Miserere et Guerre 1926,
published 1948
Series of 58 prints, photo-etching,
aquatint and drypoint on paper, 6
displayed, each 57.5 × 44.5
Fondation Georges Rouault
Plate 54 "Arise, you dead!"
(p.71)

**Frank Owen Salisbury
1874–1962**
*The Passing of the Unknown
Warrior, 11 November 1920* 1920
Oil paint on canvas, 141 × 311
Government Art Collection UK
(p.30)

Christian Schad 1894–1982
Self-Portrait 1927
Oil paint on wood, 76 × 62
Tate. Lent from a private collection
1994 (p.95)

Oskar Schlemmer 1888–1943
Abstract Figure 1921
Bronze, 105.5 × 62.5 × 21.4
Kröller-Müller Museum, Otterlo,
The Netherlands (p.114)

*Two constructive heads (sketch
for a metal sculpture)* 1921–2
Ink on paper, 30.4 × 23.7
Staatsgalerie Stuttgart,
Graphische Sammlung acquired
1951 (Not illustrated)

Sketch for a wire sculpture 1921–2
Graphite and ink on paper,
30.4 × 23.7
Staatsgalerie Stuttgart,
Graphische Sammlung,
acquired 1951
(Not illustrated)

Rudolf Schlichter 1890–1955
Phenomenon Works 1919–20
Gouache, textiles and watercolour
on paper, 61.7 × 46.6
Private collection (Not illustrated)

Jenny 1923
Oil paint on canvas, 75 × 62
Von der Heydt–Museum
Wuppertal (p.93)

Georg Schrimpf 1889–1938
Midday Rest 1922
Oil paint on canvas, 61 × 55
Museum Kunstpalast, Düsseldorf,
Germany (p.88)

Swineherd 1923
Oil paint on canvas, 49.5 × 60
Museum Ludwig, Cologne,
Germany (p.83)

Kurt Schwitters 1887–1948
*Picture of Spatial Growths –
Picture with Two Small Dogs*
1920–39
Oil paint, wood, paper, cardboard
and china on board, 97 × 69 × 11
Tate. Purchased 1984 (p.65)

Paul Segieth 1884–1969
*Fort Douaumont under French
Fire* c.1916–18
Oil paint on canvas, 92.5 × 125
Bayerisches Armeemuseum,
Germany (p.25)

Charles Sims 1873–1928
*The Old German Front Line,
Arras, 1916* 1919
Oil paint on canvas 182.8 × 317.5
IWM (Imperial War Museums),
London (p.28)

Stanley Spencer 1891–1959
Christ Carrying the Cross 1920
Oil paint on canvas, 153 × 142.9
Tate. Presented by the
Contemporary Art Society 1925
(p.87)

*Unveiling Cookham War
Memorial* 1922
Oil paint on canvas, 155 × 147.5
Private collection (p.38)

**Sasha Stone 1895–1940 and
Cami Stone 1892–1975**
*Berlin, Bird's Eye View, Radio
Tower Restaurant* 1928
Photograph, gelatin silver print on
paper, 22.8 × 16.7
Galerie Berinson, Berlin (p.119)

Henry Tonks 1862–1937
Private Charles Deeks 1916
Pastel on paper, 27 × 20
Hunterian Museum at the Royal
College of Surgeons, London (p.51)

Private Charles Deeks 1917
Pastel on paper, 28 × 21
Hunterian Museum at the Royal
College of Surgeons, London (p.51)

Gunner Wilkins c.1917
Pastel on paper, 27 × 21
Hunterian Museum at the Royal
College of Surgeons, London
(Not illustrated)

*Portrait of an Unknown
Serviceman* c.1917
Pastel on paper, 27 × 21
Hunterian Museum at the Royal
College of Surgeons, London
(Not illustrated)

*Portrait of an Unknown
Serviceman* c.1917
Pastel on paper, 27 × 21
Hunterian Museum at the Royal
College of Surgeons, London
(Not illustrated)

*Portrait of an Unknown
Serviceman* 1917
Pastel on paper, 28 × 22
Hunterian Museum at the Royal
College of Surgeons, London
(Not illustrated)

*Portrait of an Unknown
Serviceman* c.1917
Pastel on paper, 28 × 22
Hunterian Museum at the Royal
College of Surgeons, London
(Not illustrated)

Private William Riley 1917
Pastel on paper, 28 × 21
Hunterian Museum at the Royal
College of Surgeons, London
(Not illustrated)

Félix Vallotton 1865–1925
*Military Cemetery at
Châlons-sur-Marne* 1917
Oil paint on canvas, 54 × 84
Bibliothèque de Documentation
Internationale Contemporaine
(BDIC) (p.27)

Road at St Paul (Var) 1922
Oil paint on canvas, 80.6 × 64.5
Tate. Presented by Paul Vallotton,
the artist's brother 1927. (p.81)

Curators' Acknowledgements

Our first and greatest debt is to the many lenders to this exhibition whose generosity has allowed us to do justice to this important topic. We are very grateful to colleagues in museums and galleries throughout Britain, Germany, France and the Netherlands for their enthusiasm for the show, which allowed us to make the international narrative that was so important to the aims of the exhibition, and their readiness to lend key objects from their collections. We are also extremely grateful to the private lenders to the exhibition who have temporarily parted with works from their walls.

It would not be possible to curate an exhibition of this kind together without drawing on the expertise of many specialists and we have incurred many debts to colleagues who have generously shared their knowledge. Particular thanks are due to Michael White for conversations which helped to shape the direction of the show in its early stages and for his invaluable advice throughout. We would also like to thank catalogue authors Simon Martin, Catherine Moriarty and Dorothy Price for alerting us to relevant material in their specialist areas. We are also extremely grateful to many individuals who generously shared their knowledge or helped with archival research during the development of the show and would like to thank Catherine Amé, Simon Baker, Lisa Bartholomes, Aldo Battaglia, Marc Beaumelle, Marie Bionnier, Antje Birthälmer, Jonathan Black, Marion Bornscheuer, Laura Brandon, Anne-Pascale Bruneau-Rumsey, Ralf Burmeister, Cyrile Burte, Ina Conzen, Gordon Cooke, Irene Dimitrakopoulou, Johnny Dobbyn, Sarah Crellin, Patrick Elliott, Kristina Engels, Andrew Fetherston, Caroline Fieschi, Monika Flacke, Douglas Flower, Antje Hanack, Inge Herold, Corinna Höper, Ysanne Holt, Sophie Krebs, Delphine Levy, Annelie Lütgens, Jean-Yves Martel, Shoair Mavlian, Siân Miller, Anne Monfort, Brigitte Müller, Didier Ottinger, Helen Peden, Cathy Power, Maria Rollo, Inga Rossi-Schrimpf, Dieter Scholz, Anna Schultz, Richard Slocombe, Chris Stephens, Maike Steinkamp, Andrew Stephenson, Holly Trusted, Sarah Victoria Turner, Anne Vieth, Alan Wakefield and Alex Walton.

At Tate we would particularly like to thank James Brandon, Lauren Buckley, Gillian Buttimer, Cecily Carbone, Lee Cheshire, Sionaigh Durrant, Camille Feidt, Valeria Fioretti, Zuzana Flaskova, Rosie Freemantle, Matthew Gale, Juleigh Gordon-Orr, Simon Grant, Mikei Hall, Rebecca Hellen, Carolyn Kerr, Lara Kingsbeer, Abi Laughton, Minnie Scott, Gates Sofer, Vic Sowerby and Katy Wan.

The catalogue has been beautifully designed by Lorenz Klingebiel. Alice Chasey and Roanne Marner at Tate Publishing skilfully steered the catalogue through the editorial and production stages, while Emma O'Neill brought characteristic thoroughness to the picture research.

Emma Chambers
Curator, Modern British Art, Tate

Rachel Rose Smith
Assistant Curator, Modern British Art, Tate

Image Credits